The Elimination of Satan's Tail

The Elimination of Satan's Tail

Gnostic Psychology, Meditation, and the Origins of Suffering

Samael Aun Weor

Thelema Press
2007

The Elimination of Satan's Tail
A Thelema Press Book / 2007

English Edition © 2007 Thelema Press

Originally published in Spanish as "Mensaje de Navidad 1964-1965 (La Disolucion del Yo)."

ISBN 978-1-934206-17-1

Thelema Press is a non-profit organization delivering to humanity the teachings of Samael Aun Weor. All proceeds go to further the distribution of these books. For more information, visit our website.

www.gnosticteachings.org
www.gnosticradio.org
www.gnosticschool.org
www.gnosticstore.org
www.gnosticvideos.org

Contents

Introduction: The Organization of our Psyche........................... 1

 The Sensual Mind.. 1

 The Psychological Man and Woman..................................... 3

 The Three Factors... 8

 Energy & the Creation of the Superior Bodies 8

 Identification.. 9

 Intuition.. 15

Chapter One: The Kundabuffer Organ................................... 19

Chapter Two: The Ens Seminis.. 25

Chapter Three: The Seven Cosmos 29

 The Ray of Creation.. 31

Chapter Four: The Psychological "I" 37

Chapter Five: Return and Reincarnation............................... 41

Chapter Six: The Dissolution of the "I".................................. 45

Chapter Seven: The Struggle of the Opposites 49

Chapter Eight: The Technique of Meditation........................ 53

Chapter Nine: Ecstasy... 57

Glossary ... 61

Index... 69

Illustrations

The Seven Centers of our Psyche.. 3
The Monad and the Bodies of the Soul.. 12
The Seven Cosmos and the Tree of Life ... 16
Solar Wisdom ... 24
Moses and the Duality of the Serpent ... 27
The Seven Cosmos .. 30
The Wheel of Samsara, our Valley of Tears 38
Return and the Wheel of Destiny... 42
The Dissolution of the "I"... 44

Introduction

The Organization of our Psyche

Let us start our discussion that we could denominate "Intuition." First of all, we must begin from the foundation: the human being. Where did we come from? Where are we going? What is the reason for our existence? What do we exist for? Why do we exist? Behold, we have here a lot of questions that we must clarify and resolve.

A child is born, and as a fact he receives a physical body in a gratuitous form; this is obvious. This physical body is marvelous. It has about 15,000 x a million neurons that are in the service of the child, and it cost him nothing.

The Sensual Mind

While the child is growing, his sensual mind is opening little by little. This sensual mind in itself and by itself gives the child information through external sensorial perceptions and it is precisely with the information granted through such perceptions that the sensual mind always elaborates the contents of its concepts; because of this, our present mind can never know anything about reality. Its reasoning processes are subjective; they move within a vicious circle: the circle of external sensorial perceptions; this is obvious.

Now you will comprehend for yourselves, maybe a little more clearly, what subjective reasoning is in itself, but a complete differentiation between subjective reasoning and objective reasoning must be made.

It is obvious that the child has to go through all the educational processes: kindergarten, elementary, high school, and university. The subjective reasoning is nourished with all the data that these distinct scholastic institutions grant unto it. But truly no educational institute can give to a child, youth, or teenager existing data about that which is not of time, about that which is Reality.

Truly, the speculations of subjective reasoning always arrive at *intellectualism*, at the absurd field of utopianism or, in the best cases, towards simple opinions of a subjective type, but never to

the experience of the truth, never to experience that which is not from time.

On the other hand, objective reasoning, that disgracefully does not receive any instruction because there is no school that teaches it, remains abandoned. Undoubtedly, objective reasoning processes obviously conduct us towards exact and perfect postulates.

The child is always subjectively educated from place to place; for him, no form of superior instruction exists. All data, all scholastic matters, all family matters, etc. that the senses grant to the subjective mind of the teenager, are merely empirical and subjective, and this is pitiful.

Towards the beginning, the child has still not lost the capacity of astonishment. Obviously the child looks in wonder on any phenomena: a beautiful toy awakens in him this astonishment, and with this toy the child plays. This capacity of wonder disappears as the child grows, as his sensual mind receives data from school and collage. Finally, the instant in which the child becomes a youth arrives and complete loss of this capacity of astonishment.

Unfortunately, the data that one receives in collages, schools, and educational centers only serves to nourish the sensual mind, and nothing else. In this way, with these educational systems of schools, academies, and universities, the only thing that we can really achieve is to make for ourselves an artificial personality†.

To give an account of this, in reality, truly, the knowledge that is studied in Humanities will never serve to form the Psychological Human Being. In the name of truth, we have to say clearly that the topics that are currently studied in educational institutes do not have any real relationship with the distinct parts of our Being. Therefore, these topics serve only to:

First: Falsify the knowledge of the five cylinders of the organic machine [See illustration, next page].

Second: Take the capacity of astonishment away from us.

Third: Develop the sensual mind.

Fourth: Form a false personality within us.

Therefore, it should be clearly understood that the sensual mind cannot produce any radical transformation in any way within

ourselves. It is very convenient to understand that the sensual mind can never take us from the autonomism and mechanicity, in which we find the people of all the world, even if they appear to be people of a very cultured mind.

It is one thing to be an animalistic human being, an intellectual animal, while it is certainly quite another thing to be a true Psychological Man. Naturally, when I use the word "Man," I also mean Woman. But this must be clearly understood.

The Psychological Man and Woman

We were born with a marvelous physical body, but really we truly need to make something more. To form a physical body is not difficult, because we inherit it, but to form is a Psychological Man is very difficult. We do not need to work upon ourselves in order to form a physical body, but it is very obvious that we need to work upon ourselves in order to form a Psychological Man.

As a matter of fact, in order to create a Psychological Man, who is a true Man in the most complete sense of the word, we need to organize the psyche which is disorganized.

THE SEVEN CENTERS OF OUR PSYCHE

Gnostic Psychology recognizes that humanoids actually have three centers of intelligence within: an intellectual brain, an emotional brain, and a motor/instinctive/sexual brain. These are not physical brains; they are divisions of organized activity within our psychic and physiological vehicles. Seen in more detail, these three brains can be arranged as five separate centers. But for those who awaken the dormant functions of the psyche, there are two additional, superior centers (one intellectual and one emotional) that provide access to the wisdom and guidance of the Divine.

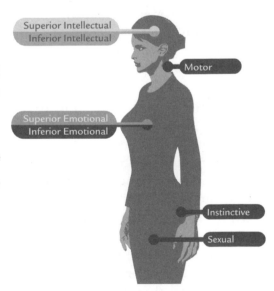

The Master Gurdjieff said that the organic machine does not have a psychology. I have to strongly disagree with him on this matter. A psychology really exists within any organic machine that we mistakenly call "man." The fact is that this machine is very disorganized. If it is true that we want to create the true Man, who is the Psychological Man, then it is urgent, unpostponable, and undeferable that we organize this psychology within the intellectual animal.

Let us then see the difference between the intellectual animal, mistakenly called Man, and the true and authentic Psychological Man. If we want to create such a Man within, then we need to work upon ourselves. Nonetheless, there is a struggle within us because the sensual mind is the clear enemy of the superior mind.

The sensual mind is identified with any circumstance; for example, if suddenly we find ourselves at a sumptuous banquet and we identify ourselves a great deal with the food, we will convert ourselves into gluttons; or if we get identified with the wine, we end up drunk. If we see a person of the opposite sex in front of us who is fascinating and interesting, we will become very identified with that person and end up fornicating, or simply, we are changed into adulterers. To create the Psychological Man in these circumstances, in this way, is not possible.

If in some way we have to start the work of creating the Psychological Man, this will come from real, true work on ourselves, without ever getting identified with any circumstance, while observing ourselves from instant to instant, from moment to moment.

There are some people who are mistaken about the path. There are societies, schools, orders, lodges, religions, sects, which pretend to organize the human psyche by means of certain golden maxims. Some communities pretend to achieve something that they call "purifications" or "sanctity" by means of such maxims. It is urgent that we analyze all of this.

It is obvious that any type of ethical or religious maxim can never serve as a pattern for the distinct events of life. For example, a maxim that is structured with superior logic, like the logic of Ouspensky, will never truly create a new cosmos, neither a new nature. To strictly subordinate ourselves to a maxim with the

purpose of organizing our psyche would be absurd. Obviously this would signify the conversion of ourselves into slaves.

Therefore, it is convenient that we should reflect upon many ethical catalogs and moral codes that are held as golden maxims.

Moreover, there is a lot that needs to be analyzed before entering into the work of the organization of the psyche. For example, a demonstrative annunciation, even if very wise and perfect, could still be unquestionably false, or even worse, intentionally false.

Accordingly, in order to anticipate a transformation within ourselves, we have to become a little more individualistic. I am not saying to become selfish: this must be understood. We must learn to think better, in a more independent and perfect way, other than through many sacred sayings, through many golden maxims, and as already mentioned, through aphorisms that all the world considers perfect. These maxims will never serve as patterns of measurement in order to achieve the authentic transformation and in order to achieve the organization of the psyche within ourselves.

The fact of the matter is to organize the interior psyche, and we have to leave behind all subjective rationalism in order to get to the root of the matter. To confront our own errors as they are without justifying them does not mean that we must flee from them. Do not intend to excuse them. There is a need to become more serious in the analysis. We must be more judicious, more comprehensive.

If we truly do not search for evasiveness, then we can work on ourselves in order to achieve the organization of the Psychological Man and stop being intellectual animals, as we are at this very moment.

Psychological Self-observation is basic. Truly, to observe ourselves from instant to instant, from second to second, is necessary.

What is the purpose of Self-observation? The discovery of our different types of psychological defects. But, they must be discovered in the field of action, by directly and judiciously observing them, without evasion, without justification, without any type of escape.

Once a defect has been discovered, then, and only then, can we comprehend it, and when we attempt to comprehend it, we

must, I repeat, be severe with ourselves. Many, when they attempt to comprehend an error, they justify it or evade it, or try to hide it from themselves. This is absurd.

There are some little Gnostic brothers and sisters who, when discovering this or that defect in themselves, begin with their mind, as we will say, their theoretical mind, to make up speculations. This is very grave because - as I already said and I repeat again in this moment - speculations of the merely subjective mind forcibly dump themselves into the field of utopianism; this is obvious.

Therefore, if an error is what we want to understand, then mere subjective speculations must be eliminated, and in order for them to be eliminated, it is necessary to have been directly observing the error. Only like this, through the means of correct observation, is it possible to correct the tendency towards speculation.

Once we have integrally comprehended any psychological defect in all of the levels of the mind, then one can have the luxury of breaking and disintegrating it, reducing it to ashes, to cosmic dust. Nevertheless, we must never forget that the mind by itself cannot radically alter any defect at all. The mind by itself can label any defect with different names, pass defects from one level to the other, to hide them from itself or to hide them from other defects, but it can never disintegrate a defect.

Many times I have taught here that we need a power superior to the mind, a power that can truly reduce to ashes any defect of a psychological type. Fortunately, this power exists in the depth of our psyche. I am clearly referring to Stella Maris, the Virgin of the Sea, a variation of our own Being. She is a derivative of our Being. If we concentrate ourselves on this variant force that exists within our psyche, that force that some civilizations denominated as Isis, others Tonantzin, others Diana, etc., then we will be assisted and the defect in question can be reduced to cosmic dust.

Once any psychological aggregate, the vivid personification of this or that error, has been disintegrated, something is liberated: this is what is called Essence†. It is clear that within any of those bottles which are known as "psychic aggregates†," some Essence or animated consciousness exists, bottled up. So when breaking this or that error, the percentage of Essence which has been placed or embottled there is liberated.

Each time a percentage of Buddhic Essence is liberated, the percentage of Consciousness increases as a fact. Likewise, while we are breaking these psychic aggregates, the percentage of awakened consciousness will multiply, and when the totality of the psychic aggregates is reduced to ashes, likewise the consciousness will awaken in its totality.

If we just break fifty percent of the inhuman undesirable elements, then obviously we will possess fifty percent of objective, awakened consciousness. But if we attain the destruction of a hundred percent of our undesirable elements, we will attain - as a fact and for our own right - one hundred percent Objective consciousness. Thus, based on incessant multiplications, our consciousness will shine each time more and more; this is obvious.

To attain absolute awakening is what we want, and this is possible if we march on the correct path. If we do the contrary, then to attain this will be impossible. This is clear.

In any case, in the same way that we are diminishing the undesirable psychic elements that we carry in our interior, distinct siddhis or luminous faculties will bloom within our psyche, and when the Buddhist Annihilation has been achieved, truly then we will achieve the most absolute Illumination.

This word "Buddhist Annihilation" bothers very much other determined organizations of a pseudo-esoteric, pseudo-occult type. For us, instead of this word sickening us, it really pleases us, because to attain one hundred percent consciousness is what we long for.

There are many that would like to achieve illumination; there are many that feel themselves to be bitter, who suffer within darkness, who suffer through the bitter circumstances of life.

Illumination is something that we long for, but illumination has to have a reason to be; the reason for illumination to be is the Dharmadatu†. This word of Sanskrit origin sounds very strange to the ears of the people present here. Dharmadatu comes from the root word "Dharma†."

The Three Factors

Someone can disintegrate the undesirable psychic elements that we carry in our interior, but nevertheless, based on this alone, one cannot achieve radical illumination, because something else enters into the game here: the Third Factor for the revolution of the consciousness: sacrifice for humanity.

If we do not sacrifice ourselves for humanity, to attain absolute illumination will not be possible, because I repeat, the reason for illumination is the Dharmadatu.

It is obvious that if we disintegrate the ego we will receive our payment. It is true, really true, that if we create the superior, existential bodies of the Being, we will be paid. We cannot deny that if we sacrifice ourselves for our fellow men we will be paid. All of this is undoubtable.

Therefore in order to achieve absolute illumination, we need to work with the three factors for the revolution of the consciousness:

TO BE BORN; meaning the creation of the existential, superior vehicles of the Being;

TO DIE; meaning the disintegration of the ego in its entirety;

and the SACRIFICE FOR HUMANITY.

Behold the three factors for the revolution of the consciousness.

Anyway, as I was telling you, we need to know how to work upon ourselves. We need to organize the Psychological Man within each one of us. First of all, before we achieve the absolute illumination, the Psychological Man must be born in us, and he is born in us when the psyche is organized. There is a need to organize the psyche within ourselves here and now.

Energy & the Creation of the Superior Bodies

If we work correctly, we will organize the psyche. For example, if we do not waste the energies of the emotional center, if we do not waste the energies of the mind, or the energies of the motor/

instinctive/sexual brain, then it is obvious that we will create or we will build, give form, to the second psychological body with the savings of such energies in ourselves: this is the body of emotions, denominated Eidolon [Solar Astral Body].

Undoubtedly, if we liberate ourselves from the sensual mind, then in reality we will achieve the savings of the intellectual energies. With such energies we can nourish the third psychological body or individual mind [Solar Mental Body].

When I pronounce myself against the sensual mind, I want the brothers and sisters to clearly understand that I am not putting aside my recognition of the usefulness of the sensual mind; we need to live in perfect equilibrium whilst knowing how to drive the superior mind and knowing how to drive the sensual mind.If one does not know how to drive the sensual mind, then one forgets that there is a need to pay the rent, there exists a need to eat in order to exist, one forgets there is a need to get dressed and not wander on the streets completely negligent, not accomplishing his duties in life. Therefore, the sensual mind is necessary, but there is a need to know how to intelligently drive it with equilibrium, meaning: the superior mind and the sensual mind must be equilibrated in life.

Some people only preoccupy themselves with the sensual mind. For example, certain hermits that live in the caverns of the Himalayas forget that they have a sensual mind. To simply disregard this mind just like that is absurd. There is a need for the sensual mind to function in a equilibrated form in order for one to accomplish his duties of life.

Identification

The struggle between the superior mind and the sensual mind is frightful. Let us remember the Christ when he was fasting in the wilderness. A demon was presented in front of him and told him, "All of the kingdoms of the world will be granted unto thee, if thou kneel and worship before me." In other words, it is the sensual mind tempting him.

The superior mind answers, saying, "Satan, Satan, it is written you must obey and worship the Lord your God."

Jesus never let the sensual mind dominate him, but the meaning of this is not that the sensual mind is useless, it just happens that there is a need to have it under control. It must march in perfect equilibrium with the superior mind.

When striving for the organization of the Psychological Man, obviously a frightful struggle will happen between the two minds, between the superior, which is the psychological one, and the sensual one. The sensual mind does not want to be involved in anything related with the superior mind. The sensual mind enjoys when it is identified with a scene of lust or when it is identified with a painful event of the street, or when it is identified with a glass of wine, etc. and the psychological mind is violently against it. I am going to illustrate this with an example

I was traveling in a car; someone else was driving that car. We were driving in the left lane of the street, and in the right lane a lady was driving another vehicle; suddenly she changed direction intent on going to a supermarket which was on the left side of the street. It is obvious that driving in the right lane she should have turned in a more correct way in order to go to the supermarket. If the supermarket was on the right side, then she would have turned right with no problem. Absolutely not caring a bit about this situation, this lady then turned left: this of course ended up with her crashing into the car that we were riding in.

The damages for her car were not so grave, they were minimal. But here comes the interesting part of the story: the car in which my insignificant person was riding was being driven by someone who recognized that this was not his fault, and truly it was not his fault, he was not guilty of crashing into this other vehicle that suddenly appeared in front of him. Naturally, he presented his allegation to the lady in question. But this lady was insisting that she was right. Of course this was manifestly absurd; any traffic officer would have disqualified her claims immediately.

Nevertheless, she insisted on calling the insurance company in order to arrange the problem. After a couple of hours, the insurance company did not arrive, and this lady insisted that she should receive payment of 300 pesos (pesos are the currency of Mexico), that was more or less the cost for the repair of her vehicle that she herself destroyed.

The occupants of the car that I was in and the driver were definitely angry in a very big way, and even if any of them could have paid her, they were not in any position to do it. Such was the anger that they were having. I decided, on my part, not to identify with this circumstance, because our psychological discipline, our psychological judo, teaches us that in such cases one must not identify. It is obvious that I remained serene in accordance with our psychological judo.

However, time was passing by, two hours, and possibly many more. We waited because the insurance agent was not showing up. At the end, this lady - very respectably - approached me, because she saw that I was the only one that was serene: the rest of the occupants were all very vociferous. She said, "Sir, if you would give me at least 300 pesos then we could be finished with this discussion, since I am wasting my time - actually, all of us are wasting our time."

"But if you observe the positions of the two cars, you will see that you were coming from the right lane and if you wanted to turn left, you should have been in the left lane; however, you intended to enter the supermarket from the right lane when the left was already occupied. It is not possible to try to enter in this way. Any traffic officer would disqualify you."

"But sir, what are we doing by wasting our time, since the insurance agent is not coming."

"O.K., take your 300 pesos and leave in holy peace, there is no problem anymore. Go on your way."

It is obvious that there was a general protest from the others; they were very indignant not only against this lady, but also against me. Such was the state in which they were, and they could not do anything but protest. They were absolutely identified with the event and of course they judged me as a fool, etc., etc, etc. and other sorts of names. Of course, one of the occupants directly approached the ladies with the purpose of insulting them because there were many, the one that was driving and her acquaintances. I approached and said to this lady "Go ahead, leave in holy peace and do not pay attention to their insults."

Well, this woman left very happy and from afar gave me a last salutation, and then the car was lost on the streets of the city. We

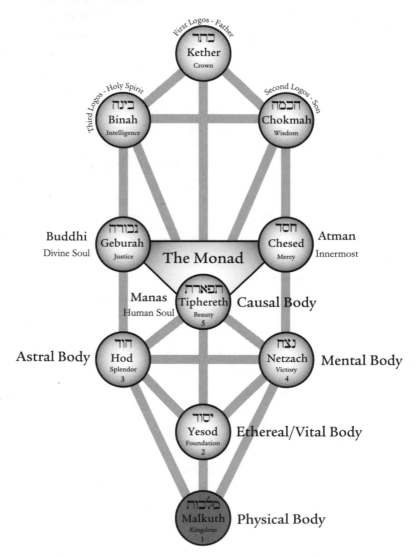

THE MONAD AND THE BODIES OF THE SOUL

could have kept waiting for three, four, six hours, even the whole afternoon, and quite possibly until that night we could have waited until the insurance agent finally arrived in order to get to some foolish arrangement.

Really, there was not a grave problem. The damages of her car were minimal; although the occupants of the other car had money, they were in no way prepared to pay her. They were so identified with the scene that obviously they didn't have any desire, as is said, to twist their arm. I certainly saved them from a great deal of problems and obnoxious details. Possibly I even saved them from going to court; I averted for them fifty thousand foolish deeds, bitter deeds, and arguments. But they were so identified with this event that they didn't realize the good that I did for them. This is how people are.

Therefore, my dear friends, in reality, truly, you must understand that to identify oneself with circumstances always brings problems. It is absurd to identify oneself with circumstances, completely absurd, because the energies are wasted. With which energies will we organize the Astral Body if we allow ourselves to be driven by explosions of anger, explosions of frightful rage, and those irritations that do not have a reason for being? And all of this because we identify with circumstances.

With which forces can one give oneself the luxury of creating an individual mind, if truly one squanders the intellectual energies wasting them on foolishness, like the event that I have been talking about?

The creation of the second body invites us to save the emotional energies, and the creation of a third body (which can be called the intellectual body or individual mind) makes us comprehend the necessity to save our mental energy.

Now then, if we truly do not learn to leave aside the mechanical antipathies, if we are always full of evil will towards our fellow man, with which energies will we create the fourth psychological body, the Body of Conscious Will (Causal Body)?

There is a need to create all of these superior vehicles if we truly want to create the Psychological Man within ourselves, or to give form to it or to build it within ourselves.

We know well that someone who possesses the physical body, a second body of an emotional/psychological type, a third body of an individual mental type, and finally a fourth body of a conscious volitive type, can give himself the luxury of receiving the animated principles in order to convert oneself into a Man; this is undoubtable. But truly, if one squanders his motor, vital, emotional, mental, and volitive energies by identifying himself with all the circumstances of life, then it is obvious that he will never organize the psychological bodies. They are indispensable in order for the Man to appear within each one of them.

Therefore, when I am speaking of the organization of the psyche, it must be understood that we must know how to handle and utilize these energies. We should not to identify ourselves, nor forget ourselves, in order not to waste our energies foolishly. When one forgets the self, then one identifies oneself, and when one is identified, then one cannot give form to the psyche: one cannot make the psyche become intelligently structured within itself because one squanders the energies foolishly. To understand this is urgent, my dear brothers and sisters.

Therefore, a true Man or Woman is one that has saved his energies and that has built the superior existential bodies of the Being by means of the same energies. A true Man is one that has received his animated and spiritual principles; a perfect Man is one that has disintegrated all of the psychic inhuman elements. A real Man is the one who has formed the interior Man inside himself instead of those undesirable elements (ego).

Therefore, what counts is the interior Man. This interior Man receives his payment; the Great Law pays him, because this interior Man is awakened and because he has disintegrated the ego. This is the real, true Man who sacrifices himself for his fellowmen. Obviously, this is how he attains illumination.

So to create the Man is a beginning; it is what is fundamental, and it is achieved by organizing the psyche. But many preoccupy themselves exclusively with the development of powers or inferior siddhis instead of dedicating themselves towards organizing their own intimate psyche, and this is really absurd. Where are we going to start? With the organization of the psyche? Or the development

of inferior powers? What is it that we want? We have to be judicious in the analysis, judicious in our longings. If it is powers that we looking for, we are just wasting our time miserably. I believe that what is fundamental is the organization of our inferior psyche, this is basic.

If you understand this in yourselves and work on yourselves, then you will be able to give form to the psyche, then the real Man, the true Man will be born within you.

Intuition

You must understand this. Instead of searching for inferior siddhis or inferior powers as we said, it is better to give form to the psyche.

A transcendental power exists that is born within any human being that truly has worked upon himself. I want in an emphatic form to refer to Intuition, and I mention this so that you will stop coveting powers. But what is this faculty? It has been said to us that this faculty is related to the pineal gland; I do not deny this. But what is important is to explain what its functions are.

How are we going to define Intuition? It is a direct perception of the truth without the depressing process of options. Well, this is a good definition, but I've found it very incipient. This definition is used by all of the little pseudo-esoteric and pseudo-occult schools which are around. Analysis invites us to go much deeper in this matter.

What is Intuition? It is the faculty of interpretation. Possibly Hegal with his dialectic tried to define it based on the Chinese philosophy of the yellow race.

A Chinese Empress did not understand this matter of Intuition very well. A wise man explained unto her that it was the faculty of Interpretation. This definition is correct, yet she did not understand. Then the wise man brought her a lit candle and placed it in the center of the hall, and around it he placed ten mirrors as well. It is clear that the flame of that candle was reflected in one mirror; this flame was in turn projecting a flame onto another mirror, and this other mirror was projecting it onto another, and

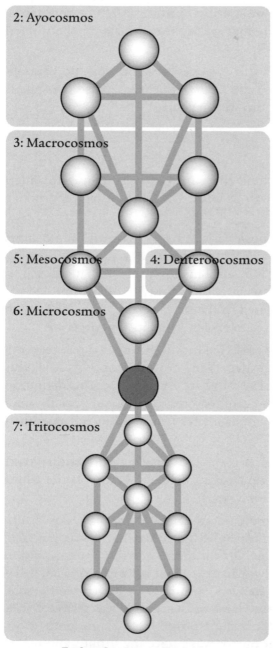

1: Protocosmos

2: Ayocosmos

3: Macrocosmos

5: Mesocosmos 4: Deuterocosmos

6: Microcosmos

7: Tritocosmos

THE SEVEN COSMOS AND THE TREE OF LIFE

this one to another. Thus they noticed that these ten mirrors were mutually projecting the light one to another. A marvelous play of lights was formed, a play with interpretation. Then the Empress understood. Behold the faculty of Intuition.

If somebody has achieved the Buddhist Annihilation, if somebody has achieved the construction of the superior existential bodies of the Being, if he is really a true Man in the most transcendental sense of the word, then the faculty of Interpretation will be a fact within him.

Let us take into account that one is contained within the cosmos. I said that one is part of the whole. Much exists within the microcosmic man, nevertheless the totality of oneself is nothing but one part of the whole.

We already know for example, that within the Ayocosmos, meaning the Infinite, the Macrocosmos is contained. Within the Macrocosmos, the Milky Way, the Deuterocosmos, the solar system is contained. Within the Deuterocosmos, the cosmic sun is contained, and within this cosmic sun, the cosmos Earth, the Mesocosmos, is contained. Likewise within the Mesocosmos is the Microcosmos man contained, and within the Microcosmos man is contained the life of the infinitely small, the Tritocosmos.

Within one cosmos, there is another cosmos, and within this cosmos, there is another one, and in totality we have seven cosmos, and these are contained one within another. Therefore, within ourselves there is an inferior cosmos (it is clear that it is the Tritocosmos) and a superior cosmos (and it is now clear that it is the Mesocosmos). We are between a superior cosmos and an inferior cosmos. We are also very related with our parents since they originated us; likewise from ourselves, our children and grandchildren come. All of us are interpreting each other mutually.

Undoubtedly, my dear friends, existence in any way, that is to say, its birth, its development, its death, remains reflecting itself as well within the true Man that has attained the Buddhist Annihilation. Therefore this Man can say, "I know the history of this planet." The whole Mahamanvantara can reflect itself in the fingernail of an authentic Man and it would be reflected with such exactitude that this Buddha would not ignore anything.

Everything that could happen within an entire nation could reflect itself in the psyche of a Man or Woman that has passed through the Buddhist Annihilation: it would reflect itself with such exactitude, with such precision, with such detail, that this one would not ignore even the most insignificant event.

Therefore deduce for yourselves and infer into what I have said about what Intuition is: the faculty of Interpretation.

If we achieve the reflection of the history of this Galaxy within ourselves, can we ignore something related with it? Of course not. The galaxy with all of its processes can be reflected within our psyche so naturally, my dear brothers and sisters, just as the candle in the example that I gave you, related with the ten mirrors that served to illustrate the story of the Empress.

If all circumstances can be reflected upon within the psyche of a Buddha of Contemplation, because this one no longer has any inhuman psychic aggregates to disintegrate, then this one achieves, as a fact, through the means of Intuition, what we would define as consciousness.

To attain Illumination is possible, but do not forget, my dear friends, that Illumination has its laws. The reason for Illumination is the Dharmadatu, in other words: Dharma.

Chapter I
The Kundabuffer Organ

Many millions of years have passed since the terrifying night of the past in which we began slowly evolving and devolving. Yet, the human being still does not know who he is, where he comes from, nor where is he going.

A lethargy of many centuries weighs over the ancient mysteries, yet the Word still awaits at the bottom of the Ark for the instant of its realization.

Behind the Edenic tradition, there is a terrible cosmic desideratum and sacred errors which frighten and horrify.

The Gods also make mistakes.

Thus, today, as at all times, we are confronting our own destiny. We face the psychological dilemma of *To be, or not to be?*

Much has been said about the sacred serpent [EDITOR: THE KUNDALINI†], yet now we are going to speak clearly about the Kundabuffer† Organ.

All of the efforts made by Prophets, Avatars, and Gods in order to end the harmful consequences of the Kundabuffer Organ have been in vain.

It is necessary to know that the Kundabuffer Organ is the negative development of the fire. This is the descending serpent, which precipitates itself from the coccyx downwards, towards the atomic infernos of the human being.

The Kundabuffer Organ is the horrifying tail of Satan, which is shown in the "body of desires" of the intellectual animal,† who in the present times is falsely called "man."

What is worst, which hurts the soul the most, is to know that the ones who gave the Kundabuffer Organ to this humanity were some sacred individuals.

Ancient traditions state that during the Lemurian† epoch certain sacred individuals came to the Earth in a cosmic starship.

These individuals formed a very high sacred Commission which was entrusted with studying the evolving and devolving problems of the Earth and its humanity.

The Archangel Sakaki and the principal archphysicist and universal-common-chemist Angel Loisos were the two main individuals from this holy divine Commission.

This sacred Commission of ineffable beings is behind the whole drama of Eden. They came with bodies of flesh and bones; their ship landed on Lemuria. During that ancient age, the human instinct was starting to develop itself into objective reasoning.

This very high Commission could verify to satiety that the Edenic human being already started to suspect the reason for his creation.

The Lemurian Root Race had started to guess the true motives of its own existence, a miserable existence with just mechanical motives.

Each human being is a little machine who captures and transforms cosmic energies, then he unconsciously adapts these energies into the interior layers of the earth. Thus, we are human machines... nothing else. What would this world be without the human machines?

Without this seal, without this physiognomy, which is supplied by this humanity, the planet would be without a purpose. Thus, everything which is without purpose ceases to exist.

Humanity as a whole is an organ from Nature. This organ collects and assimilates cosmic energies which are necessary for the development of this planetary organism. Disgracefully, to be a machine is not very pleasant, yet it is what the so-called "human being" is... he is a machine... that is what he is... yes, that, and nothing else.

When a rebel rises with his weapons against Nature, when he wants to stop being a machine, then the tenebrous powers fight against him to death.

The human beings who are capable of fighting the tenebrous forces, to fight against Nature, against the cosmos, etc., are very rare. Commonly, these type of rebels capitulate.

Many are called, yet few are chosen. Only a few individuals attain victory against Nature and achieve the right to sit on the throne of power in order to rule over it.

The Lemurians already had suspected all of this. They understood with their instinct that human beings, after having offered their services as machines to this Nature, were becoming perverse.

Everywhere, within all of the corners of Lemuria, the whole of this tragedy was instinctively suspected. Yet, this tragedy was poised to appear in the Lemurian's objective reasoning.

Therefore, this sacred Commission, after having serenely inspected this problem, resolved to take drastic cosmic procedures in order to avoid the total dissolution of the human genre and even mass suicide.

Great cosmic desiderata are behind Adam and Eve. This sacred Commission is what is hidden behind that drama and Edenic scenario. Thus, everything was fulfilled and the human being received the damned stigma, the Kundabuffer Organ.

In the course of time... maybe many centuries after... the Holy Commission returned, this time commanded by the Archseraphim Sevohtartra, due to the fact that the Archangel Sakaki had converted himself into one of the four tetra-sustainers of the Universe.

Traditions state that they returned precisely three years later. Nonetheless, these three years are always symbolic.

The fact then was that after a severe examination of the situation, the archphycisian and chemist Angel Loisos destroyed the Kundabuffer Organ from within the human race, since the human race did not need it anymore. The human being had abandoned all of his suspicions as he had become fascinated with the beauties of this world.

The Gods saved the human being from a great crisis. They achieved making the human being fascinated with this world in order that he could live within it as any planetary citizen. Yet, the Gods could not save him from the evil consequences of the Kundabuffer Organ.

Truly, the evil consequences of such an organ were converted into mistaken habits and customs that entered the depths of our psyche and became converted into the subconsciousness.

Thus, the ego[†] or the psychological "I" is the same subconsciousness that is rooted in the evil consequences of the Kundabuffer Organ.

The most saintly Ashiata Shiemash fought very hard in order to take the evil consequences of the Kundabuffer Organ out from humanity.

The Holy Lama in Tibet also suffered very much in order to save humanity from the horrifying consequences of the aforementioned fatal organ.

Buddha, Jesus, Moses, and other Masters passed through much bitterness in order to liberate humanity from the disastrous consequences of the Kundabuffer Organ.

Therefore, the Sacred Commission of Ineffable Beings threw upon their shoulders a terrible cosmic karma. They will pay such karma in the future Manvantara.[†]

Listen to me, Gnostic brothers and sisters:

You must comprehend that you can end the evil consequences of the Kundabuffer Organ only with the **three factors** of the revolution of the Consciousness.

These three factors are:

a) **Death** of the psychological "I"

b) **Birth** of the Being within us

c) **Sacrifice** for humanity

The "I" dies based on rigorous creative comprehension. The Being is born within us with the Maithuna[†] (sexual magic). Sacrifice for humanity is charity and very well understood love.

The schools which teach the ejaculation of semen, even when they do this in a very mystical way, are really Black schools, because the Kundabuffer Organ is developed with such a practice.

The schools which teach the connection of the Lingam-Yoni[†] without the ejaculation of semen are White schools because this is how the Kundalini rises through the medullar canal.

The schools which teach how to strengthen the psychological "I" are Black schools because the evil consequences of the Kundabuffer Organ are strengthened with that procedure.

The schools which teach the dissolution of the "I" (Mystical Death) are White schools because they destroy the evil consequences of the Kundabuffer Organ.

The Kundabuffer Organ is the tail of Satan. It is the sexual fire descending from the coccyx downwards towards the atomic infernos of the human being.

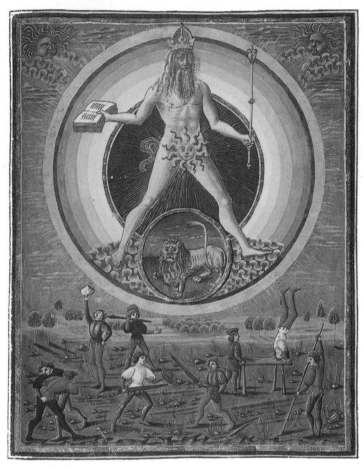

SOLAR WISDOM

The searchers yearning for the Light
knew very well through tradition that
individual Self-perfection is achieved with
the Ens Seminis. Yet, they ignored the
Tantric clue of the Maithuna. Thus, they
suffered while searching for it in vain.

Chapter 2
The Ens Seminis

Beloved Gnostic brothers and sisters:

This Christmas it is necessary for you to deeply comprehend the evolutionary and devolutionary processes that the Ens Seminis† undergoes, because with infinite patience you can find within it the whole Ens Virtutis† of the fire element.

Esoteric traditions state that after the disappearance of the Atlantean Continent, certain knowledge related to the origin and significance of the Ens Seminis survived.

Ancient traditions also state that this knowledge related with the Ens Seminis could survive the submerging of Atlantis. Yet, after thirty-five centuries of incessant wars, all of that knowledge was lost.

Ancient priests state that from all of the primeval wisdom related with the Ens Seminis, there only remained the tradition which explicitly affirms that the possibility of the realization of the Innermost Self exists with the Exioehary, semen or sperm.

Certain fragments of information which are dispersed widely in distinct places indicate to us the methods in order to work with the Ens Seminis. The primeval Aryans, descendants of the Atlanteans, tired of so many wars, started to acquire, to quest for, the esoterism of the Ens Seminis.

The searchers yearning for the Light knew very well through tradition that individual Self-perfection is achieved with the Ens Seminis. Yet, they ignored the Tantric clue of the Maithuna. Thus, they suffered while searching for it in vain.

Truly, only the ancient Egyptian, Hindustani, etc. Hierophants who were descendants of the ancient Atlantean Society called Akaldan were in possession of the whole Tantric science with the secret clue of the Maithuna.

Admission into the ancient schools of the mysteries was something very difficult because the ordeals were terrible. Thus, there were few who passed them with success.

The great quantity of yearners for the light knew nothing about the Maithuna, yet through traditions they comprehended that Self-perfection was achieved when the Ens Seminis was wisely transmuted.

The ignorant always proceed with ignorance. This is why many believed that only with mere sexual abstinence the problem of the realization of the Self was taken care of. This mistaken concept originated many communities of abstinent monks who were organized into sects and religions which ignored the Maithuna.

These ignorant people believed that the problem in order to attain their Self-perfection was resolved for them only with sexual abstinence. Ignorance was, has been, and always will be that way.

What is most grievous in this matter is that still in this day and age, not only monks but also many pseudo-occultists and pseudo-esoterists exist who are convinced that only with sexual abstinence the problem of the realization of their Innermost Self is resolved.

Formidable evolutions are within the sperm, yet there are also tremendous devolutions. For instance, the natural process of development of the sperm is evolution in itself, since the sperm is the final outcome of what we eat and drink.

It is also necessary to know that the evolutions of the sperm are submitted to the fundamental sacred cosmic Law of the Heptaparaparshinokh, which is the Law of the Holy Seven, the septenary law.

When the Ens Seminis, the sperm, has completed its septenary evolution, then it must receive an external impulse and proceed to be transmuted with the Maithuna, otherwise the Ens Seminis enters into a full process of devolution or degradation, thus converting the individual into a degenerated infrasexual.

The involution of the sperm (Ens Seminis) produces, among many other pernicious substances, one that is specifically malignant. It has the property of originating two types of actions within the general functioning of the physical organism.

The first type of action consists of triggering the deposit of superfluous fat within the organism.

The second type of action consists of originating within the human being certain malignant vibrations which are known in esoterism as Poisoninioskirian Vibrations.

The first type originates human pigs, that is to say, horrible, obese humans who are filled with fat.

The second type originates skinny, emaciated humans who are intensely charged with the perverse Poisoninioskirian Vibrations.

These type of Poisoninioskirian Vibrations manifest themselves in a dualistic way:

1. A high degree of fanaticism

2. Expert cynicism

These are, in synthesis, the dualistic manifestations of these tenebrous vibrations.

Fanaticism tends to be external, while cynicism is internal. Behold here the two sides of the same coin: the obverse and the reverse.

What is most grave in this matter of absurd sexual abstinence is that the tenebrous Poisoninioskirian Vibrations not only reinforce the evil consequences of the Kundabuffer Organ, but moreover, these vibrations can truly *develop* such a malignant organ as well.

If we take into account the fact that opposite things complement and contain each other (for instance, the darkness is within the light and vice versa; within virtue lies sin, its latent opposite, etc.), then we must comprehend in depth the word **Kundalini**.

MOSES AND THE DUALITY OF THE SERPENT

The word *kunda* reminds us of the Kundabuffer Organ, and *lini* signifies "end" in the ancient Atlantean language. Therefore, the meaning of the word *kundalini* is: "The end (elimination) of the Kundabuffer Organ."

By deeply analyzing this matter, we arrive at the logical conclusion that we need the Maithuna in order

to transmute the Ens Seminis and to eliminate not only the Kundabuffer Organ, but moreover to eliminate the remaining evil consequences of such an organ.

The hindmost vestiges of the Kundabuffer Organ are eliminated when the "I" is dissolved and the serpent of fire ascends up through the medullar canal.

This is why we can give the name of Kundalini to the sacred fire, since this name signifies: "The end (elimination) of the Kundabuffer Organ."

Chapter 3
The Seven Cosmos

Kabbalah states that two cosmos exist: The Macrocosm and the Microcosm.

The first one represents the infinitely large. The second one represents the infinitely small.

This Kabbalistic teaching about the two cosmos is incomplete, because it is only a fragmentary teaching.

Seven cosmos exist, not two, as some mistaken Kabbalists assume.

The Absolute in Itself, as explained by the Kabbalah, has three aspects, which are:

1. **Ain Soph Aur**

2. **Ain Soph**

3. **Ain**

The Ain Soph Aur is the exterior circle.

The Ain Soph is the middle circle.

The Ain is in fact, Sat, the Unmanifested Absolute.

The first cosmos could not exist within the Unmanifested Ain, not even within the Ain Soph. The first Cosmos can only exist within the Ain Soph Aur.

This first cosmos is made of an entirely spiritual nature. Its name is **Protocosmos**.

The second is the **Ayocosmos** or Megalocosmos, that is to say, the Vast Cosmos, or all of the Suns, all of the worlds of the infinite space.

The third cosmos is the **Macrocosmos**, which the Kabbalists refer to in their writings. This is formed by the Milky Way, with its eighteen million suns that gravitate around the central sun Sirius.

The fourth cosmos is the **Deuterocosmos**, which is constituted by the Sun of our Solar System and all of its laws.

The fifth is the **Mesocosmos**, our planet Earth.

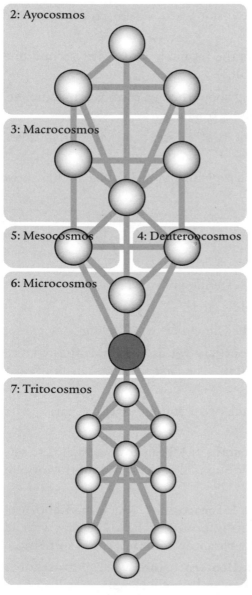

1: Protocosmos

2: Ayocosmos

3: Macrocosmos

5: Mesocosmos 4: Denterocosmos

6: Microcosmos

7: Tritocosmos

THE SEVEN COSMOS

The Gnostic Initiate has to study
the laws which govern all of these
seven cosmos, with the goal of
knowing the place that he occupies
in life and what he must do in order
to achieve the Final Liberation.

The sixth is the **Microcosm**, Man.

The seventh is the **Tritocosmos**, the infinitely small, such as atoms, molecules, insects, microbes, electrons, etc. and also the Avitchi, the Abyss.

The Mesocosmos and the Deuterocosmos exist between the Microcosm, Man, and the Macrocosm. Therefore, the phrase which states, "Man (the human being) is the Microcosm of the Macrocosm," becomes a little capricious.

Each one of the seven cosmos has its own laws. The Gnostic Initiate has to study the laws which govern all of these seven cosmos, with the goal of knowing the place that he occupies in life and what he must do in order to achieve the Final Liberation.

The Ray of Creation

The Master G. states that the Ray of Creation begins its development from the Absolute and ends in the Moon. Master G.'s mistake consists in believing that the Moon is a split-off fragment from the Earth.

The Moon is much more ancient than the Earth. It is already a dead world, a planet which belonged to another Ray of Creation.

Truly, our own Ray of Creation began in the Absolute and ended in the Inferno, Infernus, Avitchi, Greek Tartarus, Roman Averno, or Submerged Mineral Kingdom, which is the fatal abode of the sub-lunar tenebrous entities.

The proper arrangement of the Ray of Creation is as follows:

1. Absolute - Protocosmos
2. All the worlds from all of the clusters of Galaxies - Ayocosmos
3. A Galaxy or group of Suns - Macrocosmos
4. The Sun, Solar System - Deuterocosmos
5. The Earth, or any of the planets - Mesocosmos
6. The Philosophical Earth, Human Being - Microcosmos
7. The Abyss, Hell - Tritocosmos

The brothers and sisters of the Gnostic Movement must deeply comprehend the esoteric knowledge which we give in this Christmas Message, in order for them to exactly know the place that they occupy in the Ray of Creation.

We need to know the path in depth, with the goal of achieving the Nativity within our heart and the Final Liberation.

The Ray of Creation begins in the Absolute with the Protocosmos.

All of the worlds in the Ray of Creation correspond to the Ayocosmos.

All of the Suns of this Milky Way (Galaxy) correspond to the Macrocosm in the Ray of Creation.

The Deuterocosmos within the Ray of Creation is the Sun (Solar System).

Each Mesocosmos within the Ray of Creation is composed of a planet of any Solar System. Our planet Earth represents one among them.

The Microcosm is the human being within the Ray of Creation.

The Tritocosmos is the atom and the Abyss.

The unique law, the law of the Absolute, exists within the first cosmos.

The law of the first cosmos is converted into three laws within the second cosmos. Thus, three are the laws which govern the second cosmos.

The three laws are converted into six laws within the third cosmos.

The six laws are duplicated into twelve within the fourth cosmos.

The twelve laws are duplicated in order to become twenty-four laws within the fifth cosmos.

The twenty-four laws are duplicated within the sixth cosmos, thus converting into forty-eight laws.

The forty-eight laws are converted into ninety-six laws, by means of duplication, within the seventh cosmos.

Therefore, the will of the Absolute, the unique law, is fulfilled within the Protocosmos.

This great Law is converted into three within the second cosmos, which is the Father, Son and Holy Spirit, or Positive Force, Negative Force and Neutral Force.

Mechanicity starts within the third cosmos, because these three primordial laws divide themselves in order to become six laws.

Life becomes much more mechanical within the fourth cosmos, since there are no longer six laws, but twelve laws which govern in this cosmos.

Life becomes very much more mechanical within the fifth cosmos, and almost has nothing to do with the will of the Absolute, because the twelve laws have became twenty-four laws.

Life turns tremendously materialistic and mechanical within the sixth cosmos, so that the existence of the will of the Absolute is not even remotely suspected.

We live in a mechanical world of forty-eight laws, a world where the will of the Absolute is not fulfilled, a spot in a very remote corner of the universe, a terribly dark and painful place.

The position which we occupy in the Ray of Creation is sorrowful because in our world the will of the Absolute is not fulfilled, not even the will of three Divine Persons, called Father, Son and Holy Spirit, is fulfilled.

Forty-eight frightful, mechanical laws govern and direct us. We are certainly wretched, exiled ones who live in this valley of bitterness. Underneath us, in accordance with the Ray of Creation, only the disgraceful souls of the abyss exist, who are governed by the horrifying mechanism of ninety-six laws.

We need to liberate ourselves from the forty-eight laws, in order to pass into the fifth cosmos (the one of twenty-four laws).

Then we need to liberate ourselves from the fifth cosmos, in order to pass into the fourth cosmos (the one of twelve laws).

Afterwards, our work of Final Liberation continues passing from the fourth cosmos into the third, and then into the second cosmos in order to finally reach the Absolute.

All of the substances from all of the seven cosmos are within ourselves.

We have the substance of the Protocosmos within our thinking brain (head).

We have the substance of the Ayocosmos within the thinking system or motor brain (distributed throughout the spinal cord).

We have the substance of the Macrocosm within the conscious brain, which is made up of all of the specific nervous centers of the human organism, and likewise so on.

Therefore, the necessary materials for the Great Work are found within the human organism. If we achieve the creation of the Superior existential bodies of the Being, then, as a fact, we attain the liberation from all of the cosmos, including the seventh, in order to finally enter into the Unmanifested Absolute, Sat, Ain.

The seed-germs for the creation of all the existential superior bodies of the Being are found deposited within the semen.

The development of these seed-germs is necessary and is only possible with the Maithuna (sexual magic).

We have already spoken about the existential superior bodies of the Being in our former publications and messages. Therefore, our Gnostic students are already informed about the subject.

We know that the Astral Body (do not confuse it with the lunar body), is governed by twenty-four laws and that the physical body is governed by forty-eight laws.

If we create the Astral Body, then it is clear that we liberate ourselves from the fatal world of forty-eight laws. Thus, we convert ourselves into inhabitants of the world of twenty-four laws.

If we create the Mental Body, then we liberate ourselves from the world of the twenty-four laws. Thus, we enter into the world of twelve laws. Let us remember that the Mental World is governed by twelve laws.

If we create the Causal Body or the Body of the Conscious Will, then we enter into the world of six laws. Thus, we convert ourselves into inhabitants of that world, because the Body of the Conscious Will (the Causal Body) is governed by six laws.

The work with the Maithuna and the dissolution of the "I," plus the sacrifice for humanity, allows us to make new creations within ourselves, in order to be liberated from the world of six laws, thus passing beyond the Ayocosmos and the ineffable Protocosmos.

It is necessary for all of our Gnostic students to comprehend this Christmas that they can only achieve the Final Liberation by creating the Superior existential bodies of the Being, by celebrating the death of their "I," and by celebrating the Nativity in their hearts.

The Being can only enter within the one who has created the Superior existential bodies.

The Nativity of the heart can only be truly celebrated by the one who has created the Superior existential bodies of the Being.

The constitution of the intellectual animal, mistakenly called "man," is the following:

1. Physical Body
2. Vital Body
3. Lunar Body of desires
4. Lunar Mental Body
5. Pluralized "I"
6. The Buddhata

The three aspects of Atman-Buddhi-Manas, Divine Spirit, Spirit of Life, or Human Spirit, have not incarnated within the human being because he still does not possess the Solar Bodies, that is to say, the Superior existential bodies of the Being.

The whole of our efforts are aimed towards the liberation of ourselves from the moon, which disgracefully we carry within our lunar bodies.

We liberate ourselves from the lunar influence when we create the Solar Bodies.

The luxury of creating our Solar Bodies can only be achieved with the Maithuna (sexual magic), because the seed-germs of such bodies are found within the semen.

The lunar bodies keep us living in the world of forty-eight laws, in this valley of bitterness.

The lunar bodies are feminine. This is why the men from this world are within the internal worlds (after death) as subconscious, cold, phantasmagoric women.

It is very pitiable that the Theosophist and the Pseudo-Rosicrucian writers, etc., have not been capable of comprehending that the present internal vehicles of the human being are the lunar bodies which we must disintegrate, after we have created the Solar Bodies.

To liberate ourselves from the world of the forty-eight laws without having created the superior existential bodies of the Being is impossible.

Chapter 4

The Psychological "I"

The pseudo-occultists and pseudo-esoterists divide the ego into two "I's": The superior "I" and the inferior "I."

Superior and inferior are a division of one organism itself.

The superior "I" and the inferior "I" are both the "I"; they are the whole ego.

The Innermost, the real Being, is not the "I." The Innermost transcends any type of "I." He is beyond any type of "I."

The Innermost is the Being. The Being is the reality. He is what is not temporal; He is the Divine.

The "I" had a beginning and inevitably will have an end, since everything that has a beginning will have an end.

The Being, the Innermost, did not have a beginning, and so He will not have an end. He is what He is. He is what has always been and what always will be.

The "I" continues after death. The "I" returns to this valley of tears in order to repeat events, to satisfy its passions and to pay karma.

The Being does not continue, because He did not have a beginning. Only that which belongs to time is what continues, that which had a beginning.

The Being does not belong to time.

That which continues is submitted to decrepitude, degeneration, pain and passion. Our present life is the effect of our past life; it is a continuation of our past life, it is the effect of a former cause.

Every cause has its effect; every effect has its cause. Every cause transforms itself into an effect; every effect converts itself into a cause.

Our present life is the cause of our future life. The cause of our future life will be this present life with all of its errors and miseries.

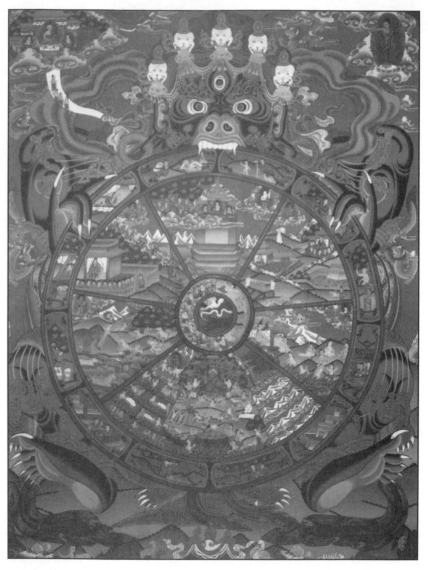

THE WHEEL OF SAMSARA, OUR VALLEY OF TEARS

The "I" is the origin of the error and
of its consequence, which is pain.
Thus, as long as the "I" exists, pain
and error will continue to exist.

To continue means to postpone our errors and pain. Therefore, what we must do is to die from instant to instant in order for us not to continue. It is better '*to be*' than to continue.

The "I" is the origin of the error and of its consequence, which is pain. Thus, as long as the "I" exists, pain and error will continue to exist.

To be born is painful, to die is painful, to live is painful. Pain exists in childhood, adolescence, youth, maturity, elderliness, because everything in this world has pain.

Pain disappears when we cease to exist in all of the levels of the mind. Only by dissolving the psychological "I" do we radically cease to exist.

The Kundabuffer Organ is the origin of the "I." The "I" is constituted by all of the evil consequences of the Kundabuffer Organ.

The "I" is a bunch of passions, desires, fears, hatred, selfishness, envy, pride, gluttony, laziness, anger, attachments, appetites, morbid sentimentalism, heritage, family, race, nation, etc.

The "I" is multiple; the "I" is not individual. The "I" exists in a pluralized state, and continues in a pluralized state, thus it returns in its pluralized state.

Therefore, as the water is compounded by many drops, as the flame is compounded by many igneous particles, as well, the "I" is compounded by many "I's."

The "I," the ego, is constituted by thousands of little "I's," which continue after death and return to this valley of tears in order to satisfy its desires and to pay karma.

As a movie of successive events, the "I's" pass in a successive order on the screen of life, in order to represent their own role within the painful drama of life.

Each "I" of this tragic movie of life has its own mind, its own ideas and criteria, since one thing, which pleases one "I," displeases another "I."

The "I" that today swears loyalty before the Gnostic Altar, is later on displaced by another "I," which hates Gnosis.

The "I" of a person which today swears eternal love to a beloved one, is later on displaced by another "I," which has nothing to do with that person or with that oath.

The intellectual animal, mistakenly called "man," has no individuality, because he does not have a Permanent Center of Gravity. He only has the pluralized "I."

Therefore, it is not strange that many people become affiliated with the Gnostic Institutions, and later on, they become enemies of them.

Today with Gnosis, and tomorrow against Gnosis. Today in one school, tomorrow in another. Today with one woman, tomorrow with another. Today a friend, tomorrow an enemy, etc.

Chapter 5
Return and Reincarnation

Return and Reincarnation are two different laws. Severe analysis brings us to the conclusion that a difference exists between returning and reincarnating.

The "I" is not an individual, since it is constituted by many "I's." Thus, every "I," even when having something from our own subconsciousness, enjoys a certain self-independence.

The "I" is a legion of devils; thus, to affirm that this legion reincarnates is an absurdity.

To affirm that an individual reincarnates is exact, yet it is not exact to affirm that the legion of "I's" reincarnate.

Millions of people exist in this world, yet it is very difficult to find an individual.

We become individuals only by creating our Superior existential bodies of the Being, by dissolving the "I," and by incarnating the Being.

The sacred individuals reincarnate, yet the "I" only returns into a new womb in order to dress, or better if we say, re-dress himself with a new suit of flesh.

The "I" continues in our mediate or immediate descendants. The "I" is the race, the error and the pain which continues.

Some pseudo-occultist ignoramuses mistakenly suppose that the personality reincarnates, thus they frequently confuse the personality with the "I."

The personality is not the "I"; the personality does not reincarnate. The personality is a daughter of its time, thus it dies in its time.

The personality is not the physical body. The personality is not the Vital Body. The personality is not the "I." The personality is not the soul. The personality is not the Spirit.

The personality is energetic, subtle, atomic, and it is formed during the first seven years in our childhood, based on heritage,

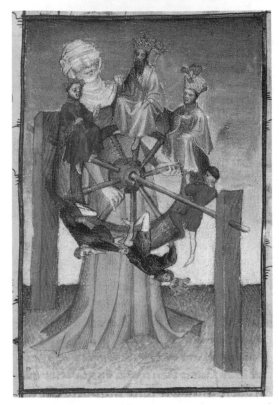

RETURN AND THE WHEEL OF DESTINY

The "I," the ego, is constituted by thousands of little "I's," which continue after death and return to this valley of tears in order to satisfy its desires and to pay karma.

customs, examples, etc. It strengthens itself with time and experiences.

Three things go into the tomb or cemetery:

1. The Physical Body
2. The Vital Body
3. The personality

The Physical and Vital Bodies disintegrate themselves little by little, in a simultaneous way. Yet, the personality wanders around the cemetery or pantheon, and only through various centuries does it become disintegrated.

The pluralized "I" is that which continues, that which is not disintegrated in the cemetery. Thus, the legion of "I's" continues with a common body. Such a body is not the Astral Body, as many people suppose.

The body that the legion of "I's" utilizes is the lunar body or Molecular Body. It is necessary for the Gnostic students not to confuse this lunar body with the Solar Body.

The Solar Body is the Astral Body.

Really, only those who have worked with the Maithuna for many years can possess the Astral Body.

The little "I's" which abide within the lunar body project themselves throughout all of the regions of the Cosmic Mind. Then, they return into their common body (the lunar body).

Thus, the "I's" dressed with the lunar body return into a new womb in order to re-dress with the suit of flesh, and to repeat the same tragedies and bitterness in this valley of tears.

Therefore, only those who possess the Being can reincarnate. Those who do not possess the Being only return.

To possess the Being is necessary in order to reincarnate. Not to possess the Being is what is necessary in order to return.

To reincarnate is a sacrifice; to return is a failure. Thus, the Sacred Individuals reincarnate in order to save the world. Yet, the imbeciles return in order to torment the world.

Sacred reincarnations were always celebrated with great religious festivities in Tibet.

Jesus of Nazareth was a reincarnation. The birth of Jesus was the greatest event of this world.

THE DISSOLUTION OF THE "I"

The greatest joy for the Gnostic
is to celebrate the discovery
of some of his defects.

Chapter 6
The Dissolution of the "I"

Brothers and sisters of mine:

This Christmas, it is necessary for you to deeply comprehend the necessity of dissolving the "I."

The greatest danger that exists in life is the danger of converting ourselves into Hanasmussen.

Whosoever does not work in the dissolution of the "I" gradually degenerates himself more and more in each existence. Finally, he does not receive any more physical bodies because he has converted himself into a dangerous Hanasmuss.

Four types of Hanasmussen exist:

1. Hanasmussen of a cretinous type, very decrepit, stupid and degenerate
2. Hanasmussen who are strong, astute and perverse
3. Hanasmussen with a double center of gravity, but without an Astral Body; they only have a lunar body
4. Hanasmussen with a double center of gravity and with an Astral Body

The Hanasmussen of the first type are true cretins, idiots and degenerated people. They are extremely perverse, yet they do not even have the strength in order to be perverse. This type is rapidly disintegrated after the death of their physical bodies.

The Hanasmussen of the second type keep returning to this world in organisms of the animal kingdom.

The Hanasmussen of the third type were Initiates of White Magic who acquired many psychic powers. Yet, they went astray from their path and fell into Black Magic, because they did not dissolve the "I." This type of Hanasmuss is like two heads of a coin, the obverse and the reverse. They have two internal personalities, one is white and the other black. Each one of these personalities has its own self-independence and psychic powers.

The Hanasmussen of the fourth type are true fallen Bodhisattvas[†], who committed the mistake of strengthening the

"I." These Hanasmussen have a double center of gravity. One is diabolical and the other divine.

What is most awful in the fourth type is that they have an Astral Body. One example of this type is Andramelek. This Hanasmuss confuses the inexperienced evocator because there are two Andrameleks, one white and the other black. Both are Adepts, yet they are opposites. Despite this, they are one. Both are true Masters, one is a Master of the White Lodge, and the other of the Black Lodge.

Many Initiates achieve the creation of their Superior existential bodies of the Being, yet they fail because they do not dissolve the psychological "I."

These Initiates cannot celebrate the Nativity in their hearts; they cannot achieve the incarnation of their Being in spite of possessing the superior existential bodies. Thus, they convert themselves into Hanasmussen with a double center of gravity.

If deep realization of the Self is what we truly want, then it is necessary to comprehend the necessity of working with the three factors of the revolution of the Consciousness.

If any of the three factors of the revolution of the Consciousness are excluded, then the outcome of this procedure is failure.

Behold the three factors of the revolution of the Consciousness: To be born, to die, and to sacrifice ourselves for humanity.

Sexual magic, dissolution of the "I," charity: This is the triple path of the righteous life.

Some Gnostic students have written to us, asking for a didactic in order to dissolve the "I."

The best didactic for the dissolution of the "I" is found in practical life that is intensely lived.

Conviviality is a marvellous full-length mirror where the "I" can be contemplated in its entirety.

The defects which are hidden in the bottom of our subconsciousness spontaneously emerge when we are in relationship with our fellow man. The defects burst out from us because our subconsciousness betrays us, and if we are in the state of alert perception, then we see them, just as they are in themselves.

The greatest joy for the Gnostic is to celebrate the discovery of some of his defects.

A discovered defect becomes a dead defect. When we discover any defect, then we should see it in action, as when one is seeing a movie, yet without judging or condemning it.

To intellectually comprehend the discovered defect is not enough. It is necessary to submerge ourselves into profound interior meditation, in order to comprehend the defect in other levels of our mind.

The mind has many levels and profundities. If we have not comprehended a defect in all the levels of the mind, then we have done nothing, because the defect continues existing as a tempting demon in the bottom of our own subconsciousness.

When a defect is integrally comprehended in all the levels of the mind, then it is disintegrated along with the small "I" which characterizes it. Thus, the defect is reduced to cosmic dust in the suprasensible worlds.

This is how we die from moment to moment. This is how we establish a Permanent Center of Consciousness, a Permanent Center of Gravity within ourselves.

The Buddhata, the interior Buddhist principle, the psychic material or the prime matter in order to build that which is called soul, exists within every human being who is not in an extreme state of degeneration.

The pluralized "I" stupidly wastes such psychic material in absurd atomic explosions of envy, greed, hatred, fornication, attachment, vanity, etc.

This psychic material is accumulated within ourselves in accordance with the death of the pluralized "I," from moment to moment. Thus, we attain a Permanent Center of Consciousness.

This is how we individualize ourselves little by little. When we rid ourselves of ego, then we become individualized.

However, we clarify that individuality is not everything, because we have to pass into the Supra-individuality when experiencing the event of Bethlehem.

The work of the dissolution of the "I" is something very serious. We need to profoundly study ourselves in all of the levels of the mind, because the "I" is a book of many volumes.

We need to study our thoughts, emotions, and actions from moment to moment, without justifying them or condemning them. We need to integrally comprehend all and every one of our defects in all of the profundities of the mind.

The pluralized "I" is the subconsciousness. When we dissolve the "I," the subconsciousness is transformed into consciousness.

We need to convert the subconsciousness into consciousness and this is only possible by achieving the annihilation of the "I."

Continuous Awakened Consciousness is acquired when our consciousness occupies the place of the subconsciousness.

Whosoever enjoys Continuous Consciousness lives conscious each and every instant, not only in the physical world, but also in the superior worlds.

This present humanity is ninety-seven percent in the subconscious. Therefore, this humanity profoundly sleeps, not only in this physical world, but also in the supra-sensible worlds during the sleep of the physical body, as well as after death.

We need the death of our "I." We need to die from moment to moment, here and now, not only in this physical world, but also in all of the planes of the Cosmic Mind.

We need to be pitiless against ourselves in order to dissect the "I" with the tremendous scalpel of self-criticism.

Chapter 7
The Struggle of the Opposites

A great master once said, "Seek enlightenment, for all else will be added onto you."

Enlightenment's worst enemy is the "I." It is necessary to know that the "I" is a knot in the flow of existence, a fatal obstruction in the flow of life free in its movement.

A master was asked, "Which is the way?"

"What a magnificent mountain!" he said, referring to the mountain where he had his haven.

"I do not ask you about the mountain, instead I ask you about the path."

"As long as you cannot go beyond the mountain, you will not be able to find the path," answered the master.

Another monk asked the same question to that same master.

"There it is, right before your eyes," the master answered him.

"Why can I not see it?"

"Because you have egotistical ideas."

"Will I be able to see it, sir?"

"As long as you have dualistic vision and you say, 'I cannot' and so on, your eyes will be blinded by that relative vision."

"When there is no I or you, can it be seen?"

"When there is no I or you, who wants to see it?"

The foundation of the "I" is the dualism of the mind. The "I" is sustained by the battle of the opposites.

All thinking is based upon the battle of the opposites. If we say such person is tall, we want to say that she is not short. If we say that we are entering, we want to say that we are not exiting. If we say that we are happy, with that we affirm that we are not sad, etc.

The problems of life are nothing more than mental forms with two poles: one positive and the other negative. Problems are sustained by the mind and are created by the mind. When we stop thinking about a problem, inevitably the latter ends.

Happiness and sadness; pleasure and pain; good and evil; victory and defeat; these constitute the battle of the opposites upon which the "I" is rooted.

We live our entire miserable life going from one extreme to another: victory, defeat; like, dislike; pleasure, pain; failure, success; this, that, etc.

We need to free ourselves from the tyranny of the opposites. This is only possible by learning how to live from moment to moment without any type of abstractions, without any dreams and without any fantasies.

Hast thou observed how the stones on the road are pale and pure after a torrential rain? One can only murmur an "Oh!" of admiration. We must comprehend that "Oh!" of things without deforming that divine exclamation with the battle of the opposites.

Joshu asked the master Nansen, "What is the TAO?"

"Ordinary life," replied Nansen.

"What does one do in order to live in accordance with it?"

"If you try to live in accordance with it, then it will flee away from you; do not try to sing that song; let it be sung by itself. Does not the humble hiccup come by itself?"

Remember this phrase: "Gnosis is lived upon facts, withers away in abstractions, and is difficult to find even in the noblest of thoughts."

They asked the master Bokujo: "Do we have to dress and eat daily? How could we escape from this?"

The master replied: "We eat, we get dressed."

"I do not comprehend," said the disciple.

"Then get dressed and eat," said the master.

This is precisely action free of the opposites: Do we eat, do we get dressed? Why make a problem of that? Why think about other things while we are eating and getting dressed?

If you are eating, eat; if you are getting dressed, get dressed, and if you are walking on the street, walk, walk, walk, but do not think about anything else. Do only what you are doing. Do not run away

from the facts; do not fill them with so many meanings, symbols, sermons and warnings. Live them without allegories, live them with a receptive mind from moment to moment.

Comprehend that I am talking to you about the path of action, free of the painful battle of the opposites.

I am talking to you about action without distractions, without evasions, without fantasies, without abstractions of any kind.

Change thy character, beloved; change it through intelligent action, free of the battle of the opposites.

When the doors of fantasy are closed, the organ of intuition awakens.

Action, free of the battle of the opposites, is intuitive action, full action; for where there is plenitude, the "I" is absent.

Intuitive action leads us by the hand towards the awakening of the consciousness.

Let us work and rest happily, abandoning ourselves to the course of life. Let us exhaust the turbid and rotten waters of habitual thinking. Thus, into the emptiness Gnosis will flow, and with it, the happiness of living.

This intelligent action, free of the battle of the opposites, elevates us to a breaking point.

When everything is proceeding well, the rigid roof of thinking is broken. Then the light and power of the Inner-Self floods the mind that has stopped dreaming.

Then in the physical world and beyond, while the material body sleeps, we live totally conscious and enlightened, enjoying the joys of life within the Superior Worlds.

This continuous tension of the mind, this discipline, takes us towards the awakening of the consciousness.

If we are eating and thinking about business, it is clear that we are dreaming. If we are driving an automobile and we are thinking about our fiancée, it is logical that we are not awake, we are dreaming; if we are working and we are remembering our child's godfather or godmother, or our friend, or brother, etc., it is clear that we are dreaming.

People who live dreaming in the physical world also live dreaming within the internal worlds (during those hours in which the physical body is asleep).

One needs to cease dreaming within the internal worlds. When we stop dreaming in the physical world, we awaken here and now, and that awakening appears in the internal worlds.

First seek enlightenment and all else will be added onto you.

Whosoever is enlightened sees the way; whosoever is not enlightened cannot see the way and can easily be led astray from the path and fall into the abyss.

Tremendous is the effort and the vigilance that is needed from second to second, from moment to moment, in order to not fall into illusions. One minute of unawareness is enough for the mind to be already dreaming about something else, distracting it from the job or deed that we are living at the moment.

When we are in the physical world, we must learn to be awake from moment to moment. We then live awakened and self-conscious from moment to moment in the internal worlds, both during the hours of the sleep of the physical body and also after death.

It is painful to know that the consciousness of all human beings sleeps and dreams profoundly not only during the hours of rest of the physical body, but also during that state ironically called the vigil state.

Action free of mental dualism produces the awakening of the consciousness.

Chapter 8
The Technique of Meditation

The technique of meditation permits us to arrive at the heights of illumination.

We should distinguish between a mind that is still and a mind that is stilled by force.

We should distinguish between a mind that is in silence and a mind that is violently silenced.

When the mind is stilled by force, it is really not still. It is gagged by violence and in the deeper levels of understanding there exists an entire tempest.

When the mind is violently silenced, it is really not in silence. Deep within, it clamors, shouts, and despairs.

It is necessary to put an end to modifications of the thinking system during meditation. When the thinking system remains under our control, illumination comes to us spontaneously.

Mental control permits us to destroy the shackles created by the mind. To achieve the stillness and silence of the mind, it is necessary to know how to live from instant to instant, to know how to take advantage of each moment, to not live the moment in doses.

Take everything from each moment, because each moment is a child of Gnosis, each moment is absolute, alive and significant. Momentariness is a special characteristic of the Gnostics. We love the philosophy of momentariness.

Master Ummom said to his disciples, "If you walk, walk; if you sit, sit, but do not vacillate."

To commence with the study of the technique of meditation is to enter into the antechamber of the divine peace that surpasses all knowledge.

The most elevated form of thinking is non-thinking. When one achieves the stillness and silence of the mind, the "I" with all its passions, dens, appetites, fears, affections, etc. becomes absent.

It is only in the absence of the "I," in the absence of the mind, that the Buddhata can awaken to unite with the Inner Self and take us to ecstasy.

The school of Black Magic of the Subub states that the Monad† or the Great Reality will penetrate in him who does not possess the Existential Bodies of the Being. This is a false statement.

What enters into those tenebrous fanatics of Subub are evil entities that express themselves through these people with gestures, actions, bestial and absurd words. Such people are possessed by the tenebrous ones.

The stillness and silence of the mind has a single objective: To liberate the Essence from the mind, so that when fused with the Monad or Inner Self, it (the Essence) can experience that which we call the Truth.

During ecstasy and in the absence of the "I," the Essence can live freely in the World of the Mist of Fire, experiencing the Truth.

When the mind is in a passive and receptive state, absolutely still and in silence, the Essence or Buddhata is liberated from the mind, and ecstasy arrives.

The Essence is always bottled up in the battle of the opposites, but when the battling ends and the silence is absolute, then the Essence remains free and the bottle is broken into pieces.

When we practice meditation, our mind is assaulted by many memories, desires, passions, preoccupations, etc.

We should avoid the conflict between attention and distraction. A conflict exists between attention and distraction when we combat those assailants of the mind. The "I" is the projector of such mental assailants. Where there is conflict, stillness and silence cannot exist.

We should nullify the projector through Self-observation and comprehension. Examine each image, each memory, each thought that comes to the mind. Remember that every thought has two poles: positive and negative.

Entering and leaving are two aspects of a same thing. The dining room and the washroom, tall and short, pleasant and unpleasant, etc. are always two poles of the same thing.

Examine the two poles of each mental form that comes to the mind. Remember that only through the study of these polarities can one arrive at a synthesis.

Every mental form can be eliminated through its synthesis. Example: The memory of a fiancé assaults us. Is she beautiful? Let us think that beauty is the opposite of ugliness, and that if in her youth she is beautiful, in her old age she will be ugly. The synthesis: It is not worthwhile to think about her; she is an illusion, a flower that inevitably withers.

In India, this Self-observation and study of our psyche is properly called Pratyahara.

Bird-like thoughts should pass through the space of our own mind in a successive parade, but without leaving any trace.

The infinite procession of thoughts projected by the "I" are exhausted in the end, and then the mind remains still and in silence.

A great Self-realized Master said, "Only when the projector, in other words, the 'I,' is completely absent, then befalls the silence which is not a product of the mind. This silence is inexhaustible, it is not of time, it is immeasurable. Only then arrives THAT which is."

This whole technique is summarized in two principles:

1. Profound reflection

2. Tremendous serenity

This technique of meditation, with its non-thinking, puts to work the most central part of the mind, the one that produces the ecstasy.

Remember that the central part of the mind is that which is called Buddhata, the Essence, the Consciousness.

When the Buddhata awakens, we remain illuminated. We need to awaken the Buddhata, the Consciousness.

The Gnostic student can practice meditation seated in the Western or Oriental style.

It is advisable to practice with eyes closed to avoid the distractions of the exterior world.

It is also convenient to relax the body carefully, avoiding any muscle remaining in tension.

The Buddhata, the Essence, is the psychic material, the inner Buddhist principle, the spiritual material or prime matter with which we will give shape to the soul.

The Buddhata is the best that we have within and awakens with profound inner meditation.

The Buddhata is really the only element that the poor intellectual animal possesses to arrive at the experience of that which we call the Truth.

The only thing that the intellectual animal can do, being unable to incarnate the Being (due to the fact that he still does not possess the superior existential bodies), is to practice meditation, to auto-awaken the Buddhata and to know the Truth.

Jesus, the Divine Master whose Nativity we celebrate this year (1964), said:

> ...*Know the Truth, and the Truth shall set you free.* John 8:32

Chapter 9
Ecstasy

Isan sent a mirror to Master Koysen, who showed it to his monks and said, "Is this Isan's mirror, or my mirror? If you say that it belongs to Isan, how is it that it is in my hands? If you say that it is mine, have I not received it from Isan's hands? Speak, speak, or else I will break it to pieces."

The monks were unable to pass between those two opposites and the Master broke the mirror into pieces.

Ecstasy is impossible as long as the Essence is bottled up in the opposites.

In the times of Babylon, the Bodhisattva of the most saintly Ashiata Shiemash, a great Avatar, came to the world.

The Bodhisattva was not fallen, and like every Bodhisattva, he had his Superior existential bodies of the Being normally developed.

When he reached a responsible age he arrived at the Vezinian mountain and entered a cavern.

The tradition narrates that he carried out three tremendous fasts of forty days, each accompanied by intentional and voluntary suffering.

He dedicated the first fast to prayer and meditation.

The second fast was dedicated to reviewing his entire life and his past lives.

The third fast was definitive. It was dedicated to putting an end to the mechanical association of the mind. He did not eat, he only drank water, and every half hour he pulled out two hairs from his chest.

There are two types of mechanical association which are the foundation of the opposites:

 a) Mechanical association by means of ideas, words, phrases, etc.

 b) Mechanical association by images, forms, things, persons, etc.

An idea associates with another, a word with another, a phrase with another, and the battle of the opposites follows.

One person associates with another, the memory of someone comes to his mind. An image associates with another, a form with another, and the battle of the opposites continues.

The Bodhisattva of the Avatar Ashiata Shiemash suffered the unutterable. Fasting for forty days, mortifying himself horribly, sunk in profound inner meditation, he achieved the disassociation from the mental mechanism, and his mind remained solemnly still and in imposing silence.

The result was ecstasy, with the incarnation of his real Being.

Ashiata Shiemash carried out a great work in Asia, founding monasteries and establishing rulers with awakened consciousness everywhere.

This Bodhisattva was able to incarnate his Real Being during meditation because he already possessed the Superior existential bodies of the Being.

Those who do not have the Superior existential bodies of the Being cannot succeed in getting the Divinity or the Being to operate or incarnate in them. However, they are able to liberate their Essence so that it will fuse with their Being and participate in His ecstasy.

In the state of ecstasy, we can study the great mysteries of life and death.

We have to study the ritual of life and death until the Officiant (the Inner-Self, the Being) arrives.

It is only in the absence of the "I" that one can experience the bliss of the Being. Only in the absence of the "I" can ecstasy be attained.

When one achieves the dissolution of the mental mechanism, then comes that which the Oriental race calls "the breaking of the bag," the eruption of the void. Then there is a shout of joy because the Essence (the Buddhata) has escaped from within the battle of the opposites, and it now participates in the communion of the Saints.

Only through the experience of ecstasy can we know what the Truth and Life is. Only in the absence of the "I" can we enjoy the ecstasy of life in its movement.

Only in the state of ecstasy can we discover the deep significance of the Nativity, which every year we always celebrate with jubilation in our hearts.

When in the state of ecstasy, we study the life of Christ. Then we discover that a great fragment of this cosmic drama represented by the Lord remains unwritten.

We must practice Gnostic meditation daily; it can be practiced alone or in a group.

This technique of meditation, taught in this book, must be established in all of the Gnostic Lumisials as an obligation, thus converting those Lumisials into centers of meditation.

All of the Gnostic Brethren must gather, sit and meditate as a group.

Every Gnostic group must practice this technique of meditation before or after the meetings of Second Chamber.

This technique of meditation also can and must be practiced daily in our homes. Those who can go out to the woods, to the country, must do so in order to meditate within the silence of the forest.

It is necessary to include within the order of the Gnostic Lumisials the technique of meditation, based on the message and the teachings of this book. Thus, we deliver the unique technique of meditation that must be accepted in all of the Lumisials.

It is false to asseverate that the Great Reality can operate inside of an individual who does not possess the Existential Bodies of the Being.

It is stupid to affirm that the Great Reality can penetrate inside of any body (as the tenebrous ones from Subub assert) in order (they say) to cast out of ourselves the instinctive, submerged animal entities which constitute the pluralized "I."

We repeat: The Great Reality cannot penetrate inside of those who do not possess the superior existential bodies of the Being. We

can create the superior existential bodies of the Being only with the Maithuna (sexual magic).

The great Avatar Ashiata Shiemash could incarnate within his Bodhisattva when the mind of the latter was in absolute quietude and silence. This was due to the concrete fact that he already was in possession of his superior existential bodies of the Being from ancient reincarnations.

It is also necessary to clarify that after the ecstasy, and in spite of having received a tremendous amount of energy, the "I" is not dissolved, as many students of occultism mistakenly believe.

The dissolution of the "I" is only possible through profound comprehension and through incessant daily work on ourselves, from instant to instant.

We explain all of this in order not to confuse the Gnostic meditation with the tenebrous practices of Subub, and many other schools of Black Magic.

When a mystic attains ecstasy, and returns into his physical body, then he feels the urgent necessity of creating the superior existential bodies of the Being and the indescribable longing of dissolving the "I."

Ecstasy is not a nebulous state, but a transcendental state of wonderment, which is associated with perfect mental clarity.

Brothers and sisters of mine: I wish for you a merry Christmas and a prosperous new year.

May the star of Bethlehem shine upon your path.

Inverential Peace,
Samael Aun Weor

Glossary

Aggregates: (Sanskrit skandha, Tibetan pungpo nga; literally "heaps") Impermanent and inhuman psychological "I's" ("egos" or defects) that fill the lower levels of consciousness and trap the psyche in suffering. Aggregates are psychological elements created by means of desire. Each aggregate traps a certain percentage of consciousness, which when freed through the destruction of the aggregate, results in the awakening of consciousness in a positive manner. In synthesis, a psychic aggregate is a positive or negative value that is the source of suffering. See also ego, defect, "I."

Black Lodge: The diabolic intelligence which seeks to pull souls into attachment to desire-sensation and the awakening of the consciousness (negatively) that is trapped within the ego. Excerpted from *The Perfect Matrimony:* "From the dawn of life, a great battle has raged between the powers of Light and the powers of Darkness. The secret root of that battle lies in sex. Gods and Demons live in eternal struggle. The Gods defend the doctrine of chastity. The Demons hate chastity. In sex is found the root of the conflict between Gods and Demons... There are Masters of the Great White Lodge. There are Masters of the Great Black Lodge. There are disciples of the Great White Lodge. There are disciples of the Great Black Lodge. The disciples of the Great White Lodge know how to move consciously and positively in the Astral Body. The disciples of the Great Black Lodge also know how to travel in the Astral Body... The White Magician worships the inner Christ. The Black Magician worships Satan. This is the "I," the me, myself, the reincarnating ego. In fact, the "I" is the specter of the threshold itself. It continually reincarnates to satisfy desires. The "I" is memory. In the "I" are all the memories of our ancient personalities. The "I" is Ahriman, Lucifer, Satan."

Black Magic: "The black magicians have their mysticism, and they always firmly believe that they walk on the good path. No black magician believes that he walks on the evil path. The path of black magic is a broad way filled with vices and pleasures." - *The Revolution of Beelzebub* "Multitudes of schools of black magic exist, many of them with very venerable traditions that teach Sexual Magic with the spilling of semen. They have very beautiful theories that attract and captivate, and if the student falls in that seductive and delicious deceit, he becomes a black magician. Those black schools affirm to the four winds that they are white and that is why ignorant ones fall. Moreover,

those schools talk of beauty, love, charity, wisdom, etc., etc. Naturally, in those circumstances the ignorant disciple attains the belief with firmness that such institutions are not evil and perverse. Remember good disciple, that the Abyss is full of sincerely mistaken ones and people of very good intentions..." - *The Initiatic Path in the Arcana of Tarot and Kabbalah* "The intellect as the negative function of the mind is demoniacal. Everyone that enters into these studies, the first thing that they want is to dominate the mind of others. This is pure and legitimate black magic. No one has the right to violate the free will of others. No one has the right to exercise coaction upon the mind of others because this is black magic. The ones that are guilty of this grave error are all of those mistaken authors that are everywhere. All of those books of hypnotism, magnetism and suggestion are books of black magic. Whosoever does not know how to respect the free will of others is a black magician; those who perform mental works in order to violently dominate the mind of others convert themselves into perverse demons. These people separate themselves from the Innermost and they crumble into the Abyss." - *The Initiatic Path in the Arcana of Tarot and Kabbalah*

Bodhisattva: (Sanskrit; Tibetan: changchub sempa) Literally, Bodhi means "enlightenment" or "wisdom." Sattva means "essence" or "goodness," therefore the term Bodhisattva literally means "essence of wisdom." In the esoteric or secret teachings of Tibet and Gnosticism, a Bodhisattva is a human being who has reached the Fifth Initiation of Fire (Tiphereth) and has chosen to continue working by means of the Straight Path, renouncing the easier Spiral Path (in Nirvana), and returning instead to help suffering humanity. By means of this sacrifice, this individual incarnates the Christ (Avalokitesvara), thereby embodying the supreme source of wisdom and compassion. This is the entrance to the Direct Path to complete liberation from the ego, a route that only very few take, due to the fact that one must pay the entirety of one's karma in one life. Those who have taken this road have been the most remarkable figures in human history: Jesus, Buddha, Mohammed, Krishna, Moses, Padmasambhava, Milarepa, Joan of Arc, Fu-Ji, and many others whose names are not remembered or known. Of course, even among bodhisattvas there are many levels of Being: to be a bodhisattva does not mean that one is enlightened. Interestingly, the Christ in Hebrew is called Chokmah, which means "wisdom," and in Sanskrit the same is Vishnu, the root of the word "wisdom." It is Vishnu who sent his Avatars into the world in order to guide humanity. These avatars were Krishna, Buddha, Rama, and the Avatar of this age: the Avatar Kalki.

Consciousness: "Wherever there is life, there exists the Consciousness. Consciousness is inherent to life as humidity is inherent to water." - *Fundamental Notions of Endocrinology and Criminology.* From various dictionaries: 1. The state of being conscious; knowledge of one's own existence, condition, sensations, mental operations, acts, etc. 2. Immediate knowledge or perception of the presence of any object, state, or sensation. 3. An alert cognitive state in which you are aware of yourself and your situation. In Universal Gnosticism, the range of potential consciousness is allegorized in the Ladder of Jacob, upon which the angels ascend and descend. Thus there are higher and lower levels of consciousness, from the level of demons at the bottom, to highly realized angels in the heights. "It is vital to understand and develop the conviction that consciousness has the potential to increase to an infinite degree." - the 14th Dalai Lama. See also: Level of Being. "Light and consciousness are two phenomena of the same thing; to a lesser degree of consciousness, corresponds a lesser degree of light; to a greater degree of consciousness, a greater degree of light." - *The Esoteric Treatise of Hermetic Astrology.* "Wherever there is light, there is consciousness." - *The Great Rebellion*

Dharma: (Sanskrit; Tibetan chö) A word with many levels of application. Righteousness, duty. The inner constitution of a thing, which governs its growth. Also, the Law or the Way. The teachings themselves are the Dharma. Likewise, the fruit of good actions, which we receive as compensation, is Dharma. Any great truth is Dharma.

Dharmadatu: (Tibetan chöying) The all-encompassing space which is unoriginated and beginingless from which all phenomena arise.

Ego: The multiplicity of contradictory psychological elements that we have inside are in their sum the "ego." Each one is also called "an ego" or an "I." Every ego is a psychological defect which produces suffering. The ego is three (related to our Three Brains or three centers of psychological processing), seven (capital sins) and legion (in their infinite combinations). "The ego is the root of ignorance and pain." - *The Esoteric Treatise of Hermetic Astrology.* "The Being and the ego are incompatible. The Being and the ego are like water and oil. They can never be mixed... The annihilation of the psychic aggregates (egos) can be made possible only by radically comprehending our errors through meditation and by the evident Self-reflection of the Being." - *The Pistis Sophia Unveiled*

Ens Seminis: (Latin) Literally, "the entity of semen." A term used by Paracelsus.

Ens Virtutis: (Latin) Literally, "army; host; mighty works (pl.); strength/power; courage/bravery; worth/manliness/virtue/character/excellence." Paracelsus stated that the ens virtutis must be extracted from the ens seminis, thus saying that all virtue and excellence is developed from the force within the sexual waters.

Essence: "Without question the Essence, or Consciousness, which is the same thing, sleeps deeply... The Essence in itself is very beautiful. It came from above, from the stars. Lamentably, it is smothered deep within all these "I's" we carry inside. By contrast, the Essence can retrace its steps, return to the point of origin, go back to the stars, but first it must liberate itself from its evil companions, who have trapped it within the slums of perdition. Human beings have three percent free Essence, and the other ninety-seven percent is imprisoned within the "I's"." - *The Great Rebellion.* "A percentage of psychic Essence is liberated when a defect is disintegrated. Thus, the psychic Essence which is bottled up within our defects will be completely liberated when we disintegrate each and every one of our false values, in other words, our defects. Thus, the radical transformation of ourselves will occur when the totality of our Essence is liberated. Then, in that precise moment, the eternal values of the Being will express themselves through us. Unquestionably, this would be marvelous not only for us, but also for all of humanity." - *The Revolution of the Dialectic*

Human Being: According to Gnostic Anthropology, a true Human Being is an individual who has conquered the animal nature within and has thus created the Soul, the Mercabah of the Kabbalists, the Sahu of the Egyptians, the To Soma Heliakon of the Greeks: this is "the Body of Gold of the Solar Man." A true Human Being is one with the Monad, the Inner Spirit. A true Human Being has reconquered the innocence and perfection of Eden, and has become what Adam was intended to be: a King of Nature, having power over Nature. The Intellectual Animal, however, is controlled by nature, and thus is not a true Human Being. Examples of true Human Beings are all those great saints of all ages and cultures: Jesus, Moses, Mohammed, Krishna, and many others whose names were never known by the public.

Intellectual animal: When the Intelligent Principle, the Monad, sends its spark of consciousness into Nature, that spark, the anima, enters into manifestation as a simple mineral. Gradually, over millions of years,

the anima gathers experience and evolves up the chain of life until it perfects itself in the level of the mineral kingdom. It then graduates into the plant kingdom, and subsequently into the animal kingdom. With each ascension the spark receives new capacities and higher grades of complexity. In the animal kingdom it learns procreation by ejaculation. When that animal intelligence enters into the human kingdom, it receives a new capacity: reasoning, the intellect; it is now an anima with intellect: an Intellectual Animal. That spark must then perfect itself in the human kingdom in order to become a complete and perfect Human Being, an entity that has conquered and transcended everything that belongs to the lower kingdoms. Unfortunately, very few Intellectual Animals perfect themselves; most remain enslaved by their animal nature, and thus are reabsorbed by Nature, a process belonging to the Devolving side of life and called by all the great religions "Hell" or the Second Death. "The present manlike being is not yet human; he is merely an intellectual animal. It is a very grave error to call the legion of the "I" the "soul." In fact, what the manlike being has is the psychic material, the material for the soul within his Essence, but indeed, he does not have a Soul yet." - *The Revolution of the Dialectic*

Kundabuffer: "It is necessary to know that the Kundabuffer Organ is the negative development of the fire. This is the descending serpent, which precipitates itself from the coccyx downwards, towards the atomic infernos of the human being. The Kundabuffer Organ is the horrifying tail of Satan, which is shown in the "body of desires" of the Intellectual Animal, who in the present times is falsely called man." - from *The Elimination of Satan's Tail*. "The diabolic type whose seduction is here, there and everywhere under the pretext of working in the Ninth Sphere, who abandons his wife because he thinks she will not be useful to him for the work in the Fiery Forge of Vulcan, instead of awakening Kundalini, will awaken the abominable Kundabuffer organ. A certain Initiate, whose name will not be mentioned in this Treatise, commits the error of attributing to the Kundalini all the sinister qualities of the Kundabuffer organ... When the Fire is cast downwards from the chakra of the coccyx, the tail of Satan appears; the abominable Kundabuffer organ. The hypnotic power of the organ of Witches' Sabbath holds the human multitude asleep and depraved. Those who commit the crime of practicing Black Tantra (Sexual Magic with Seminal Ejaculation) clearly awaken and develop the organ of all fatalities. Those who betray their Guru or Master, even if practicing White Tantra (without seminal ejaculation), will obviously activate the organ of all evils. Such sinister power opens the seven doorways of the lower abdomen (the seven

infernal chakras) and converts us into terribly perverse demons." - *The Mystery of the Golden Blossom*

Kundalini: "Kundalini is a compound word: Kunda reminds us of the abominable "Kundabuffer organ," and lini is an Atlantean term meaning termination. Kundalini means "the termination of the abominable Kundabuffer organ." In this case, it is imperative not to confuse Kundalini with Kundabuffer." - *The Great Rebellion*. These two forces, one positive and ascending, and one negative and descending, are symbolized in the Bible in the Book of Numbers (the story of the Serpent of Brass). The Kundalini is "The power of life."- from the *Theosophical Glossary*. The Sexual Fire that is at the base of all life. "The ascent of the Kundalini along the spinal cord is achieved very slowly in accordance with the merits of the heart. The fires of the heart control the miraculous development of the Sacred Serpent. Devi Kundalini is not something mechanical as many suppose; the Igneous Serpent is only awakened with genuine Love between husband and wife, and it will never rise up along the medullar canal of adulterers." - *The Mystery of the Golden Blossom*. "The decisive factor in the progress, development and evolution of the Kundalini is ethics." - *The Revolution of Beelzebub*. "Until not too long ago, the majority of spiritualists believed that on awakening the Kundalini, the latter instantaneously rose to the head and the initiate was automatically united with his Innermost or Internal God, instantly, and converted into Mahatma. How comfortable! How comfortably all these theosophists, Rosicrucians and spiritualists, etc., imagined High Initiation." - *The Zodiacal Course*. There are seven bodies of the Being. "Each body has its "cerebrospinal" nervous system, its medulla and Kundalini. Each body is a complete organism. There are, therefore, seven bodies, seven medullae and seven Kundalinis. The ascension of each of the seven Kundalinis is slow and difficult. Each canyon or vertebra represents determined occult powers and this is why the conquest of each canyon undergoes terrible tests." - *The Zodiacal Course*

Lemurian Race: The third Root Race of this terrestrial humanity. "The third Root Race was the Lemurian race, which inhabited Mu, which today is the Pacific Ocean. They perished by fire raining from the sun (volcanoes and earthquakes). This Root Race was governed by the Aztec God Tlaloc. Their reproduction was by means of gemmation. Lemuria was a very extensive continent. The Lemurians who degenerated had, afterwards, faces similar to birds; this is why some savages, when remembering tradition, adorned their heads with feathers." - *The Kabbalah of the Mayan Mysteries*

Lingam-Yoni: The sexual organs; Lingam is masculine, Yoni is feminine.

Manvantara: A period of time or an age.

Monad: (Latin) From monas, "unity; a unit, monad." The Monad is the Being, the Innermost, our own inner Spirit. "We must distinguish between Monads and Souls. A Monad, in other words, a Spirit, is; a Soul is acquired. Distinguish between the Monad of a world and the Soul of a world; between the Monad of a human and the Soul of a human; between the Monad of an ant and the Soul of an ant. The human organism, in final synthesis, is constituted by billions and trillions of infinitesimal Monads. There are several types and orders of primary elements of all existence, of every organism, in the manner of germs of all the phenomena of nature; we can call the latter Monads, employing the term of Leibnitz, in the absence of a more descriptive term to indicate the simplicity of the simplest existence. An atom, as a vehicle of action, corresponds to each of these genii or Monads. The Monads attract each other, combine, transform themselves, giving form to every organism, world, micro-organism, etc. Hierarchies exist among the Monads; the Inferior Monads must obey the Superior ones that is the Law. Inferior Monads belong to the Superior ones. All the trillions of Monads that animate the human organism have to obey the owner, the chief, the Principal Monad. The regulating Monad, the Primordial Monad permits the activity of all of its subordinates inside the human organism, until the time indicated by the Law of Karma." - *The Esoteric Treatise of Hermetic Astrology* "(The number) one is the Monad, the Unity, Iod-Heve or Jehovah, the Father who is in secret. It is the Divine Triad that is not incarnated within a Master who has not killed the ego. He is Osiris, the same God, the Word." - *Tarot and Kabbalah* "When spoken of, the Monad is referred to as Osiris. He is the one that has to Self-realize Himself... Our own particular Monad needs us and we need it. Once, while speaking with my Monad, my Monad told me, 'I am self-realizing Thee; what I am doing, I am doing for Thee.' Otherwise, why are we living? The Monad wants to Self-realize and that is why we are here. This is our objective." - *Tarot and Kabbalah* "The Monads or Vital Genii are not exclusive to the physical organism; within the atoms of the Internal Bodies there are found imprisoned many orders and categories of living Monads. The existence of any physical or supersensible, Angelic or Diabolical, Solar or Lunar body, has billions and trillions of Monads as their foundation." - *The Esoteric Treatise of Hermetic Astrology*

Personality: (Latin personae: mask) We create a new personality in the first seven years of each new physical body, in accordance with

three influences: genotype, phenotype and paratype. Genotype is the influence of the genes, or in other words, karma, our inheritence from past actions. Phenotype is the education we receive from our family, friends, teachers, etc. Paratype is related to the circumstances of life. "The personality is time. The personality lives in its own time and does not reincarnate. After death, the personality also goes to the grave. For the personality there is no tomorrow. The personality lives in the cemetery, wanders about the cemetery or goes down into its grave. It is neither the Astral Body nor the ethereal double. It is not the Soul. It is time. It is energetic and it disintegrates very slowly. The personality can never reincarnate. It does not ever reincarnate. There is no tomorrow for the human personality." - from *The Perfect Matrimony*

Sahaja Maithuna: (Sanskrit) Sahaja, "natural." Maithuna, "sacramental intercourse"

White Brotherhood: That ancient collection of pure souls who maintain the highest and most sacred of sciences: White Magic or White Tantra. It is called White due to its purity and cleanliness. This "Brotherhood" or "Lodge" includes human beings of the highest order from every race, culture, creed and religion, and of both sexes.

Index

"I" 3-6, 8-11, 13-15, 17-19, 22-23, 28, 35, 37-51, 53-55, 57-61, 63-65, 67
Absolute 7-8, 29, 31-34, 53-54, 60
Abstinence 26-27
Abstractions 50-51
Abyss 31-33, 52, 62
Action 5, 26-27, 47, 50-52, 67
Actions 26, 48, 54, 63, 68
Adam 21, 64
Adepts 46
Adolescence 39
Adulterers 4, 66
Affections 53
Age 20, 26, 55, 57, 62, 67
Ages 64
Aggregates 6-7, 18, 61, 63
Ahriman 61
Ain 29, 34
Ain Soph 29
Ain Soph Aur 29
Akaldan 25
Alert 46, 63
Altar 39
Analysis 5, 15, 41
Analyze 4
Analyzed 5
Analyzing 27
Andramelek 46
Angel 20-21
Angelic 67
Angels 63
Anger 11, 13, 39
Anima 64-65
Animal 3-4, 19, 35, 40, 45, 56, 59, 64-65
Animalistic 3
Animals 5, 65
Animated 6, 14
Annihilation 7, 17-18, 48, 63
Annunciation 5
Ant 67
Antechamber 53
Anthropology 64
Antipathies 13
Aphorisms 5

Appetites 39, 53
Arcana 62
Archangel 20-21
Archphycisian 21
Archphysicist 20
Archseraphim 21
Arguments 13
Ark 19
Army 64
Aryans 25
Ascend 63
Ascends 28
Ascension 65-66
Ashes 6-7
Ashiata Shiemash 22, 57-58, 60
Asia 58
Asleep 52, 65
Astral Body 9, 13, 34, 42-43, 45-46, 61, 68
Astrology 63, 67
Atlantean 25, 27, 66
Atlantean Continent 25
Atman-Buddhi-Manas 35
Atom 32, 67
Atomic 19, 23, 41, 47, 65
Atoms 31, 67
Attachment 47, 61
Attachments 39
Attention 11, 54
Attract 61, 67
Aur 29
Authors 62
Automobile 51
Autonomism 3
Avalokitesvara 62
Avatar 57-58, 60, 62-63
Avatars 19, 62
Averno 31
Avitchi 31
Awake 51-52
Awaken 3, 7, 52, 54-56, 65
Awakened 7, 14, 48, 52, 58, 66
Awakening 7, 51-52, 61, 65-66
Awakens 2, 51, 55-56

Aware 63

Ayocosmos 17, 29, 31-32, 34-35

Aztec 66

Babylon 57

Banquet 4

Battle 49-51, 54, 58, 61

Beauties 21

Beautiful 2, 55, 61, 64

Beauty 55, 62

Beelzebub 61, 66

Being 1-3, 5-6, 8, 10, 13-15, 17, 19-23,
 27, 31-32, 34-37, 41, 43, 46-47, 54,
 56-60, 62-67

Beings 20-22, 52, 64, 68

Belief 62

Believe 15, 60-61

Believed 26, 66

Believing 31

Bestial 54

Bethlehem 47, 60

Bible 66

Bird-like 55

Birds 66

Birth 17, 22, 43

Bitter 7, 13

Bitterness 22, 33, 35, 43

Black 22-23, 45-46, 54, 60-62, 65

Black Lodge 46, 61

Black Magic 45, 54, 60-62

Black Tantra 65

Blinded 49

Bliss 58

Bodhi 62

Bodhisattva 57-58, 60, 62

Bodhisattvas 45, 62

Bodies 8, 12, 14, 17, 20, 34-36, 41-42,
 45-46, 54, 56-60, 66-67

Body of Conscious Will 13

Body of Gold 64

Bokujo 50

Bones 20

Book of Numbers 66

Born 1, 3, 8, 15, 22, 39, 46

Bottle 54

Bottled 6, 54, 57, 64

Brain 3, 9, 34

Brains 3, 63

Brass 66

Brotherhood 68

Buddha 17-18, 22, 62

Buddha of Contemplation 18

Buddhata 35, 47, 54-56, 58

Buddhic Essence 7

Buddhist 7, 17-18, 47, 56

Buddhist Annihilation 7, 17-18

Business 51

Canal 22, 28, 66

Candle 15, 18

Canyon 66

Car 10-11, 13

Causal Body 13, 34

Cause 37

Cavern 57

Caverns 9

Cemetery 42, 68

Center 8, 15, 40, 45-47

Centers 2-3, 34, 59, 63

Central 29, 55

Centuries 19, 21, 25, 42

Cerebrospinal 66

Chain 65

Chakra 65

Chamber 59

Characteristic 53

Characterizes 47

Charity 22, 46, 62

Chastity 61

Chemist 21

Child 1-2, 51, 53

Childhood 39, 41

Children 17

Chinese Empress 15

Chokmah 62

Chosen 21, 62

Christ 9, 59, 61-62

Christmas 25, 32, 35, 45, 60

Christmas Message 32

Circle 1, 29

Circumstance 4, 11

Circumstances 4, 7, 13-14, 18, 62, 68

Civilizations 6

Clarity 60

Cleanliness 68

Coccyx 19, 23, 65

Cognitive 63

Collage 2

Commission 20-22
Communion 58
Communities 4, 26
Companions 64
Compassion 62
Complexity 65
Composed 32
Compound 66
Compounded 39
Comprehend 1, 5-6, 13, 22, 25, 27, 32, 35, 45-48, 50-51
Comprehended 6, 26, 47
Comprehending 36, 63
Comprehension 22, 54, 60
Comprehensive 5
Concentrate 6
Concept 26
Concepts 1
Condition 63
Conduct 2
Conflict 54, 61
Conscious 13-14, 34, 48, 51, 63
Conscious Will 13, 34
Consciously 61
Consciousness 6-8, 18, 22, 46-48, 51-52, 55, 58, 61, 63-64
Consequence 38-39
Consequences 19, 21-23, 27-28, 39
Contemplated 46
Contemplation 18
Continent 25, 66
Continuous 48, 51
Conviviality 46
Cord 34, 66
Cosmic 6, 17, 19-22, 26, 43, 47-48, 59
Cosmic Mind 43, 48
Cosmos 4, 16-17, 20, 29-35
Country 59
Couple 10
Courage 64
Court 13
Coveting 15
Create 3-4, 8-9, 13-14, 34-35, 60, 67
Created 35-36, 49, 53, 61, 64
Creating 4, 13, 35, 41, 60
Creation 8, 13, 20, 31-34, 46
Creations 35
Creative 22

Culture 68
Cultured 3
Cultures 64
Currency 10
Customs 22, 42
Cylinders 2
Cynicism 27
Danger 45
Dangerous 45
Dark 33
Darkness 7, 27, 61
Data 1-2
Daughter 41
Dawn 61
Dead 31, 47
Death 17, 20, 22-23, 35-37, 39, 42, 45, 47-48, 52, 58, 65, 68
Deceit 61
Decided 11
Decisive 66
Decrepit 45
Decrepitude 37
Deduce 18
Deed 52
Deeds 13
Defect 5-6, 47, 61, 63-64
Defects 5-6, 44, 46-48, 61, 64
Degenerate 45
Degenerated 26, 45, 66
Degenerates 45
Degeneration 37, 47
Degradation 26
Degree 27, 63
Demon 9, 47
Demoniacal 62
Demons 61-63, 65
Dens 53
Depraved 65
Depressing 15
Descend 63
Descendants 25, 41
Descending 19, 23, 65-66
Desiderata 21
Desideratum 19
Desire 13, 61
Desire-sensation 61
Desires 19, 35, 39, 42, 54, 61, 65
Despairs 53

Destiny 19, 42
Destroy 23, 53
Destroyed 10, 21
Destruction 7, 61
Detail 3, 18
Details 13
Deuterocosmos 17, 29, 31-32
Develop 2, 20, 27, 63, 65
Developed 22, 57, 64
Development 14, 17, 19-20, 26, 31, 34, 65-66
Devi Kundalini 66
Devils 41
Devolution 25-26
Devolving 19-20, 65
Dharma 7, 18, 63
Dharmadatu 7-8, 18, 63
Diabolic 61, 65
Diabolical 46, 67
Dialectic 15, 64-65
Diana 6
Didactic 46
Die 8, 39, 46-48
Dies 22, 41
Direct 15, 33, 62
Direct Path 62
Direction 10
Disassociation 58
Disciple 50, 62
Disciples 53, 61
Discipline 11, 51
Discover 47, 59
Discovered 5, 47
Discovering 6
Discovery 5, 44, 47
Discussion 1, 11
Disintegrate 6, 8, 18, 36, 42, 64
Disintegrated 6, 14, 42, 45, 47, 64
Disintegrates 68
Disintegrating 6
Disintegration 8
Dissect 48
Dissolution 21, 23, 35, 44-48, 58, 60
Dissolve 45-46, 48
Dissolved 28, 60
Dissolving 39, 41, 45, 60
Distinct 1-2, 4, 7, 25
Distinguish 53, 67

Distracting 52
Distraction 54
Distractions 51, 55
Distributed 34
Divide 33, 37
Divine 3, 20, 33, 35, 37, 46, 50, 53, 56, 67
Divine Triad 67
Divinity 58
Division 37
Divisions 3
Doctrine 61
Dominate 10, 62
Doors 51
Doorways 65
Dormant 3
Doses 53
Double 45-46, 68
Drama 20-21, 39, 59
Drank 57
Dreaming 51-52
Dreams 50, 52
Dress 41, 50
Dressed 9, 43, 50
Drink 26
Driving 10-11, 51
Drops 39
Drunk 4
Dualism 49, 52
Dualistic 27, 49
Duality 27
Duplication 32
Dust 6, 47
Duties 9
Duty 63
Earth 17, 19-20, 29, 31-32
Earthquakes 66
Eat 9, 26, 50, 57
Eating 50-51
Ecstasy 54-55, 57-60
Eden 20, 64
Edenic 19-21
Educated 2
Education 68
Educational 1-2
Effect 37
Effort 52
Efforts 19, 35

Ego 8, 14, 22, 37, 39, 42, 47, 61-63, 67
Egos 61, 63
Egotistical 49
Egyptian 25
Egyptians 64
Eidolon 9
Eighteen 29
Ejaculation 22, 65
Elderliness 39
Electrons 31
Element 25, 56
Elementary 1
Elements 7-8, 14, 61, 63, 67
Eliminate 28
Eliminated 6, 28, 55
Elimination 27-28, 65
Embottled 6
Emotional 3, 8, 13-14
Emotions 9, 48
Emphatic 15
Empress 15, 17-18
Emptiness 51
Enemies 40
Enemy 4, 40, 49
Energetic 41, 68
Energies 8-9, 13-14, 20
Energy 8, 13, 60
Enjoy 59
Enjoying 51
Enjoys 10, 41, 48
Enlightened 51-52, 62
Enlightenment 49, 52, 62
Ens Seminis 24-28, 64
Ens Virtutis 25, 64
Enslaved 65
Entity 64-65
Entrance 62
Entrusted 20
Envy 39, 47
Epoch 19
Equilibrium 9-10
Error 6, 38-39, 41, 62, 65
Errors 5, 19, 37, 39, 63
Eruption 58
Escape 5, 50
Escaped 58
Esoteric 25, 32, 62-63, 67
Esoterism 25, 27

Essence 6-7, 54-58, 62, 64-65
Eternal 40, 61, 64
Ethereal 68
Ethical 4-5
Ethics 66
Evasion 5-6
Evasions 51
Eve 21
Event 10-11, 13, 18, 43, 47
Events 4, 37, 39
Evil 13, 21-23, 27-28, 39, 50, 54, 61-62, 64
Evils 65
Evocator 46
Evolution 26, 66
Evolutionary 25
Evolves 65
Evolving 19-20
Exact 2, 41
Exactitude 17-18
Examination 21
Examine 54-55
Excellence 64
Exercise 62
Exhaust 51
Exhausted 55
Exiled 33
Exioehary 25
Existence 1, 17, 20, 33, 45, 49, 63, 67
Existential 8, 14, 17, 34-36, 41, 46, 54, 56-60
Existential Bodies 8, 14, 17, 34-36, 41, 46, 54, 56-60
Existing 1, 47
Exiting 49
Experience 2, 54, 56, 58-59, 65
Experiences 42
Experiencing 47, 54
Expert 27
Explosions 13, 47
Express 54, 64
Extensive 66
Exterior 29, 55
External 1, 26-27
Extracted 64
Eyes 49, 55
Face 19
Faces 66

Fact 1, 3-5, 7, 17-18, 21, 27, 29, 34, 56, 60-62, 65
Factor 8, 66
Factors 8, 22, 46
Facts 50-51
Faculties 7
Faculty 15, 17-18
Failure 43, 46, 50
Fall 52, 61
Fallen 45, 57
Falls 61
False 2, 5, 54, 59, 64
Falsify 2
Family 2, 39, 68
Fanaticism 27
Fanatics 54
Fantasies 50-51
Fantasy 51
Fascinated 21
Fascinating 4
Fasting 9, 58
Fasts 57
Fat 26-27
Fatal 22, 31, 34, 49
Fatalities 65
Father 33, 67
Fault 10
Fears 39, 53
Feathers 66
Fell 45
Feminine 36, 67
Festivities 43
Fiancé 55
Fiancée 51
Field 1, 5-6
Fiery 65
Fiery Forge of Vulcan 65
Fifth 29, 32-33, 62
Fifth Initiation of Fire 62
Fifty 7, 13
Fight 20
Figures 62
Finished 11
Fire 19, 23, 25, 28, 54, 62, 65-66
Five 2-3
Flame 15, 39
Flesh 20, 41, 43
Floods 51

Flow 49, 51
Flower 55
Food 4
Fool 11
Foolishness 13
Force 6, 33, 53, 64
Forces 13, 20, 66
Forest 59
Forge 65
Forget 6, 9, 14, 18
Form 1-3, 9, 13-15, 53, 55, 58, 67
Formed 14, 17, 20, 29, 41
Forms 49, 57
Fornicating 4
Fornication 47
Forty 57-58
Forty-eight 32-36
Foundation 1, 49, 57, 67
Founding 58
Four 13, 21, 45, 61
Fourth 2, 13-14, 29, 32-33, 45-46
Fragment 31, 59
Fragmentary 29
Fragments 25
Free 49-52, 54, 56, 62, 64
Freed 61
Friend 40, 51
Friends 13, 17-18, 68
Frighten 19
Front 4, 9-10
Fruit 63
Fu-Ji 62
Full 13, 26, 51, 62
Function 9, 62
Functioning 26
Functions 3, 15
Fundamental 14-15, 26, 63
Fuse 58
Fused 54
Future 22, 37
Galaxies 31
Galaxy 18, 31-32
Game 8
Gather 59
Gathers 65
Gemmation 66
General 11, 26
Genes 68

Genii 67
Genotype 68
Genre 21
Germs 67
Gestures 54
Gland 15
Glass 10
Gluttons 4
Gluttony 39
Gnosis 39-40, 50-51, 53
Gnostic 3, 6, 22, 25, 30-32, 34-35, 39-
 40, 43-44, 46-47, 55, 59-60, 64
Gnostic Altar 39
Gnostic Anthropology 64
Gnostic Initiate 30-31
Gnostic Institutions 40
Gnostic Lumisials 59
Gnostic Movement 32
Gnostic Psychology 3
Gnosticism 62-63
Gnostics 53
Goal 30-32
God 9, 66-67
Godfather 51
Godmother 51
Gods 19, 21, 61
Gold 64
Golden 4-5, 66
Good 13, 15, 50, 61-63
Goodness 62
Govern 30-33
Governed 33-34, 66
Governs 63
Grades 65
Graduates 65
Grandchildren 17
Grant 1-2
Granted 1, 9
Grave 6, 10, 13, 27, 62, 65, 68
Gravitate 29
Gravity 40, 45-47
Great Law 14, 33
Great Work 34, 58
Greed 47
Greek 31
Greeks 64
Group 31, 59
Growing 1

Grows 2
Growth 63
Guidance 3
Guide 62
Guilty 10, 62
Gurdjieff 4
Guru 65
Habits 22
Habitual 51
Half 57
Hall 15
Hanasmussen 45-46
Hand 2, 51
Handle 14
Hands 57
Happiness 50-51
Happy 11, 49
Harmful 19
Hate 61
Hates 39
Hatred 39, 47
Head 34, 66
Heads 45, 66
Heart 32, 35, 66
Hearts 35, 46, 59
Hebrew 62
Hegal 15
Heights 53, 63
Heliakon 64
Hell 31, 65
Heptaparaparshinokh 26
Heritage 39, 41
Hermetic 63, 67
Hermits 9
Hiccup 50
Hidden 21, 46
Hierarchies 67
Hierophants 25
High Initiation 66
Himalayas 9
Hindustani 25
History 17-18, 62
Holy Commission 21
Holy Spirit 33
Homes 59
Hour 57
Hours 10-11, 13, 52

Human Being 1-3, 15, 19-21, 23, 27, 31-32, 35-36, 47, 62, 64-65
Human Beings 20-21, 52, 64, 68
Human Spirit 35
Humanities 2
Humanity 8, 19-20, 22, 35, 46, 48, 62, 64, 66
Humanoids 3
Humans 27
Humidity 63
Husband 66
Hypnotic 65
Hypnotism 62
Idea 58
Ideas 39, 49, 57
Identification 9
Identified 4, 10-11, 13-14
Idiots 45
Igneous 39, 66
Igneous Serpent 66
Ignoramuses 41
Ignorance 26, 63
Ignorant 26, 61-62
Ignore 17-18
Ignored 24-26
Illuminated 55
Illumination 7-8, 14, 18, 53
Illusion 55
Illusions 52
Illustrate 10, 18
Illustration 2
Image 54, 58
Images 57
Imagined 66
Imbeciles 43
Immeasurable 55
Imperative 66
Impermanent 61
Imposing 58
Impossible 7, 36, 57
Imprisoned 64, 67
Impulse 26
Incarnate 56, 58, 60
Incarnated 35, 67
Incarnates 62
Incarnating 41
Incarnation 46, 58
Incessant 7, 25, 60

Incipient 15
Incompatible 63
Incomplete 29
Increase 63
Increases 7
Independent 5
India 55
Individual 9, 13-14, 24-26, 39, 41, 59, 62, 64
Individualistic 5
Individuality 40, 47
Individuals 19-21, 41, 43
Ineffable 20, 22, 35
Inexhaustible 55
Inexperienced 46
Inferior 14-15, 17, 37, 67
Inferior Monads 67
Infernal 65
Inferno 31
Infernos 19, 23, 65
Infernus 31
Infinite 17, 25, 29, 55, 63
Influence 35, 68
Influences 68
Information 1, 25
Infrasexual 26
Inhabitants 34
Inhabited 66
Inheritence 68
Inhuman 7, 14, 18, 61
Initiate 30-31, 65-66
Initiates 45-46
Initiatic 62
Initiation 62, 66
Inner Self 54
Inner Spirit 64, 67
Inner-Self 51, 58
Innermost 25-26, 37, 62, 66-67
Innermost Self 25-26
Innerself 51, 58
Innocence 64
Insects 31
Instinct 20-21
Instinctive 3, 9, 59
Instinctively 21
Institute 1
Institutes 2
Institutions 1, 40, 62

Instruction 2
Insults 11
Insurance 10-11, 13
Intellect 62, 65
Intellectual 3-5, 9, 13, 19, 35, 40, 56,
 64-65
Intellectual Animal 3-4, 19, 35, 40, 56,
 64-65
Intellectual Animals 5, 65
Intellectualism 1
Intellectually 47
Intelligence 3, 61, 65
Intelligent 51, 64
Intelligent Principle 64
Intelligently 9, 14
Intend 5
Intended 11, 64
Intent 10
Intentional 57
Intentions 62
Intercourse 68
Interior 5, 7-8, 14, 20, 47
Internal 27, 36, 45, 52, 66-67
Internal Bodies 67
Internal God 66
Interpretation 15, 17-18
Interpreting 17
Intuition 1, 15, 17-18, 51
Intuitive 51
Involution 26
Iod-Heve 67
Irritations 13
Isan 57
Isis 6
Jacob 63
Jehovah 67
Jesus 10, 22, 43, 56, 62, 64
Job 52
John 56
Joshu 50
Joy 44, 47, 58
Joys 51
Jubilation 59
Judged 11
Judging 47
Judicious 5, 15
Judo 11
Justification 5

Justify 6
Justifying 5, 48
Kabbalah 29, 62, 66-67
Kabbalistic 29
Kabbalists 29, 64
Karma 22, 37, 39, 42, 62, 67-68
Kindergarten 1
King of Nature 64
Kingdom 31, 45, 65
Kingdoms 9, 65
Kneel 9
Knot 49
Know 1, 8-9, 14, 17, 19, 26, 32, 34, 49,
 52-53, 56, 59, 61-62, 65
Knowing 9, 30-31
Knowledge 2, 25, 32, 53, 63
Koysen 57
Kunda 27, 66
Kundabuffer 19, 21-23, 27-28, 39,
 65-66
Kundabuffer Organ 19, 21-23, 27-28,
 39, 65-66
Kundalini 19, 22, 27-28, 65-66
Ladder of Jacob 63
Lady 10-11
Lama 22, 63
Language 27
Latin 64, 67
Law 14, 26, 32-33, 63, 67
Law of Karma 67
Layers 20
Laziness 39
Learn 5, 13, 52
Learning 50
Learns 65
Legion 41-43, 63, 65
Legitimate 62
Leibnitz 67
Lemuria 20-21, 66
Lemurian 19-21, 66
Lemurian Root Race 20
Lemurians 21, 66
Lethargy 19
Level 6, 63, 65
Level of Being 63
Levels 6, 39, 47-48, 53, 61-63
Liberate 9, 22, 33-36, 54, 58, 64
Liberated 6-7, 35, 54, 64

Liberation 30-35, 62
Lies 27, 61
Life 4, 7, 9, 14, 16-17, 30-31, 33, 35, 37, 39, 45-46, 49-51, 57-59, 61-63, 65-66, 68
Light 17, 24-27, 51, 61, 63
Lingam-Yoni 22, 67
Lini 27, 66
Lodge 46, 61, 68
Lodges 4
Logic 4
Logical 27, 51
Loisos 20-21
Longing 60
Longings 15
Lot 1, 5
Love 22, 40, 53, 62, 66
Loyalty 39
Lucifer 61
Luminous 7
Lumisials 59
Lunar 34-36, 43, 45, 67
Lunar Body 34-35, 43, 45, 67
Lust 10
Luxury 6, 13-14, 35
Machine 2, 4, 20
Machines 20-21
Macrocosm 29, 31-32, 34
Macrocosmos 17, 29, 31
Magic 22, 34-35, 45-46, 54, 60-62, 65, 68
Magician 61-62
Magnetism 62
Mahamanvantara 17
Mahatma 66
Maithuna 22, 24-27, 34-35, 43, 60, 68
Majority 66
Malignant 26-27
Man 3-5, 8, 10, 13-15, 17-19, 31, 35, 40, 46, 64-65
Manifest 27
Manifestations 27
Manlike 65
Manliness 64
Manvantara 22, 67
March 7, 10
Maris 6
Mask 67

Mass 21
Master 4, 31, 46, 49-50, 53, 55-57, 65, 67
Master G. 31
Master Gurdjieff 4
Masters 22, 46, 61
Material 47, 51, 56, 65
Materialistic 33
Materials 34
Matter 3-5, 15, 26-27, 47, 56
Maturity 39
Maxim 4
Maxims 4-5
Mean 3, 5, 62
Meaning 8-10, 17, 27, 66
Meanings 51
Means 4, 6, 14, 18, 32, 39, 57, 61-62, 66
Measurement 5
Mechanical 13, 20, 33, 57, 66
Mechanicity 3, 33
Mechanism 33, 58
Mediate 41
Meditate 59
Meditation 47, 53-60, 63
Medullar 22, 28, 66
Meetings 59
Megalocosmos 29
Memories 54, 61
Memory 54-55, 58, 61
Men 8, 36
Mental 9, 13-14, 34-35, 49, 52-55, 58, 60, 62-63
Mental Body 9, 34-35
Mental World 34
Merits 66
Mesocosmos 17, 29, 31-32
Message 32, 59
Messages 34
Methods 25
Mexico 10
Microbes 31
Microcosm 29, 31-32
Microcosmos 17, 31
Microorganism 67
Middle 29
Milky 17, 29, 32
Milky Way 17, 29, 32
Million 1, 29

Millions 19, 41, 64
Mind 1-4, 6, 8-10, 13, 39, 43, 47-49, 51-
 55, 57-58, 60, 62
Minds 10
Mineral 31, 64-65
Minimal 10, 13
Mirror 15, 46, 57
Mirrors 15, 17-18
Miserable 20, 50
Miseries 37
Mist of Fire 54
Mistake 31, 45
Mistaken 4, 22, 26, 29, 62
Mistakenly 4, 35, 40-41, 60
Mistakes 19
Mixed 63
Modifications 53
Mohammed 62, 64
Molecular Body 43
Molecules 31
Moment 4-6, 47-48, 50-53, 64
Momentariness 53
Monad 12, 54, 64, 67
Monasteries 58
Money 13
Monk 49
Monks 26, 57
Moon 31, 35
Moral 5
Morbid 39
Mortifying 58
Moses 22, 27, 62, 64
Motor 3, 8, 14, 34
Mountain 49, 57
Move 1, 61
Movement 32, 49, 59
Movie 39, 47
Multiple 39
Multiplications 7
Multiplicity 63
Multiply 7
Multitude 65
Multitudes 61
Murmur 50
Muscle 56
Mutually 17
Myself 9, 61
Mysteries 19, 25, 58, 66

Mystic 60
Mystical 22-23
Mystical Death 23
Mysticism 61
Name 2, 28-29, 65
Names 6, 11, 62, 64
Nansen 50
Nation 18, 39
Nativity 32, 35, 46, 56, 59
Nature 4, 20-21, 29, 64-65, 67
Nazareth 43
Nebulous 60
Negative 19, 33, 49, 54, 61-62, 65-66
Negative Force 33
Negatively 61
Negligent 9
Nervous 34, 66
Neurons 1
Neutral Force 33
New 4, 35, 41, 43, 60, 65, 67
Night 13, 19
Ninety 32-33
Ninety-seven 48, 64
Ninth Sphere 65
Nirvana 62
Nothing 1-2, 17, 20, 26, 33, 40, 47, 49
Notions 63
Nourish 2, 9
Nourished 1
Nullify 54
Number 67
Numbers 66
Oath 40
Obese 27
Obey 9, 67
Object 63
Objective 1-2, 7, 20-21, 54, 67
Obligation 59
Observation 6
Observe 5, 11
Observed 50
Observing 4-6
Obstruction 49
Obverse 27, 45
Occultism 60
Occupants 11, 13
Occupied 11
Occupies 30-31, 48

Occupy 32-33
Officer 10-11
Officiant 58
Oil 63
Operate 58-59
Operations 63
Opinions 1
Opposite 4, 27, 55
Opposites 46, 49-51, 54, 57-58
Options 15
Ordeals 25
Orders 4, 67
Organ 19-23, 27-28, 39, 51, 65-66
Organic 2, 4
Organism 20, 26, 34, 37, 66-67
Organisms 45
Organization 1, 3, 5, 7, 9-11, 13-15, 17
Organize 3-5, 8, 13-14
Organized 3, 8, 26
Organizing 5, 14
Organs 67
Oriental 55, 58
Origin 7, 25, 38-39, 64
Originated 17, 26
Originates 27
Osiris 67
Ouspensky 4
Pacific Ocean 66
Padmasambhava 62
Pain 37-39, 41, 50, 63
Painful 10, 33, 39, 51-52
Pantheon 42
Paracelsus 64
Parade 55
Paratype 68
Parents 17
Participate 58
Particles 39
Passions 37, 39, 53-54
Passive 54
Past 19, 37, 57, 68
Path 4, 7, 32, 45-46, 49, 51-52, 60-62
Patience 25
Pattern 4
Patterns 5
Peace 11, 53, 60
Penetrate 54, 59

People 3-4, 7, 9, 13, 26, 40-42, 45, 52, 54, 62
Percent 7, 48, 64
Percentage 6-7, 61, 64
Perception 15, 46, 63
Perceptions 1
Perdition 64
Perfect 2, 5, 9-10, 14, 60-61
Perfection 64
Perfects 65
Perform 62
Period 67
Perished 66
Permanent 40, 47
Permanent Center of Consciousness 47
Permanent Center of Gravity 40, 47
Person 4, 10, 40, 49, 58
Personae 67
Personalities 45, 61
Personality 2, 41-42, 67-68
Personification 6
Persons 33, 57
Perverse 21, 27, 45, 62, 65
Pesos 10-11
Phantasmagoric 36
Phenomena 2, 63, 67
Phenotype 68
Philosophical 31
Philosophy 15, 53
Physical 1, 3, 14, 26, 34-35, 41-42, 45, 48, 51-52, 60, 67
Physical Body 1, 3, 14, 34-35, 41-42, 48, 52, 60, 67
Physiognomy 20
Physiological 3
Pigs 27
Pineal gland 15
Pitiable 36
Pitiful 2
Pitiless 48
Planes 48
Planet 17, 20, 29, 31-32
Planetary 20-21
Planets 31
Play 17
Plays 2
Pleasant 20, 54
Pleases 7, 39

Pleasure 50
Pleasures 61
Plenitude 51
Pluralized 35, 39-40, 42, 47-48, 59
Poisoninioskirian Vibrations 27
Polarities 55
Poles 49, 54-55
Position 11, 33
Positions 11
Positive 33, 49, 54, 61, 66
Positive Force 33
Possess 7, 35, 43, 54, 56, 59
Possessed 54, 58
Possesses 14, 56
Possessing 46
Possession 25, 60
Postulates 2
Potential 63
Power 6, 15, 21, 51, 64-66
Powers 14-15, 20, 45, 61, 66
Practical 46
Practice 22, 54-56, 59
Practiced 59
Practices 60
Pratyahara 55
Prayer 57
Precision 18
Preoccupations 54
Preoccupy 9, 14
Presence 63
Present 1, 7, 19, 36-37, 48, 65
Pretend 4
Pretext 65
Pride 39
Priests 25
Primary 67
Prime 47, 56
Primeval 25
Primordial 33, 67
Primordial Monad 67
Principal 20, 67
Principal Monad 67
Principle 47, 56, 64
Principles 14, 55
Problem 10-11, 13, 21, 26, 49-50
Problems 13, 20, 49
Procedure 23, 46
Procedures 21

Process 15, 26, 65
Processes 1-2, 18, 25
Processing 63
Procession 55
Procreation 65
Produce 2
Produces 26, 52, 55, 63
Product 55
Profound 47, 55-56, 58, 60
Profundities 47-48
Progress 66
Project 43
Projected 55
Projecting 15, 17
Projector 54-55
Pronounce 9
Property 26
Prophets 19
Prosperous 60
Protest 11
Protocosmos 29, 31-35
Pseudoesoteric 7, 15
Pseudoesoterists 26, 37
Pseudooccult 7, 15
Pseudooccultist 41
Pseudooccultists 26, 37
Psyche 1, 3-9, 11, 13-15, 17-18, 22, 55, 61
Psychic 3, 6-8, 14, 18, 45, 47, 56, 61, 63-65
Psychological 2-6, 8-11, 13-14, 19, 22-23, 37, 39, 46, 61, 63
Psychological Human Being 2
Psychological Man 3-5, 8, 10, 13
Psychological Self-observation 5
Psychology 3-4
Public 64
Publications 34
Pure 50, 62, 68
Purifications 4
Purity 68
Purpose 5, 11, 20
Qualities 65
Quantity 26
Quest 25
Question 6, 10, 49, 64
Questions 1
Quietude 60

Race 15, 20-21, 39, 41, 58, 66, 68
Radical 2, 8, 64
Rage 13
Raged 61
Rain 50
Raining 66
Rama 62
Range 63
Rare 20
Rationalism 5
Ray 31-33
Ray of Creation 31-33
Real 2, 4, 14-15, 37, 58
Reality 1-2, 9, 13, 37, 54, 59
Realization 19, 25-26, 46
Realize 13
Realized 63
Reason 1, 7-8, 13, 18, 20
Reasoning 1-2, 20-21, 65
Rebel 20
Receive 2, 8, 10, 26, 45, 63, 68
Received 14, 21, 57, 60
Receives 1-2, 14, 65
Receiving 14
Receptive 51, 54
Recognition 9
Recognized 10
Recognizes 3
Reconquered 64
Redress 41, 43
Reduced 6-7, 47
Reflect 5, 17-18
Reflected 15, 17-18
Reflection 18, 55
Regions 43
Regulating 67
Reincarnate 41, 43, 68
Reincarnates 41, 61
Reincarnation 41, 43
Reincarnations 43, 60
Relationship 2, 46
Relative 49
Relax 56
Religion 68
Religions 4, 26, 65
Religious 4, 43
Remember 9, 34, 50, 54-55, 62
Remembered 62

Remembering 51, 66
Renouncing 62
Repeat 6, 8, 37, 43, 59
Replied 50
Represent 39
Represented 59
Represents 29, 32, 66
Reproduction 66
Resolve 1
Resolved 21, 26
Respect 62
Respectably 11
Responsible 57
Rest 11, 51-52
Result 58
Results 61
Retrace 64
Return 39, 41-43, 64
Returned 21
Returning 41, 45, 62
Returns 37, 39, 41, 60
Reverse 27, 45
Reviewing 57
Revolution 8, 22, 46, 61, 64-66
Right 7, 10-11, 21, 49, 62
Righteous 46
Righteousness 63
Rigid 51
Rigorous 22
Rise 66
Rises 20, 22
Ritual 58
Road 50, 62
Role 39
Roman 31
Roof 51
Room 54
Root 5, 7, 20, 61-63, 66
Root Race 20, 66
Rooted 22, 50
Rose 66
Rosicrucian 36
Rosicrucians 66
Rotten 51
Route 62
Rule 21
Rulers 58
Sabbath 65

Sacramental 68
Sacred Commission 20-22
Sacred Individuals 19, 41, 43
Sacred Serpent 19, 66
Sacrifice 8, 22, 35, 43, 46, 62
Sacrifices 14
Sad 49
Sadness 50
Sahaja Maithuna 68
Sahu 64
Saintly 22, 57
Saints 58, 64
Sakaki 20-21
Salutation 11
Samael 60
Samsara 38
Sanctity 4
Sanskrit 7, 61-63, 68
Sat 29, 34
Satan 9, 19, 23, 61, 65
Satiety 20
Satisfy 37, 39, 42, 61
Sattva 62
Savages 66
Scalpel 48
Scenario 21
Scene 10, 13
Scholastic 1-2
School 1-2, 40, 54
Schools 2, 4, 15, 22-23, 25, 60-62
Science 25
Sciences 68
Screen 39
Sea 6
Seal 20
Search 5
Searchers 24-25
Searching 15, 24-25
Seated 55
Second 2, 5, 9, 13-14, 27, 29, 32-33, 45, 52, 57, 59, 65
Second Chamber 59
Second Death 65
Secret 25, 61-62, 67
Sects 4, 26
Seduction 65
Seductive 61
See 2, 4, 11, 46-47, 49, 52, 61, 63

Seeing 47
Seek 49, 52
Seeks 61
Self 14, 25-26, 46, 54
Self-conscious 52
Self-criticism 48
Self-independence 41, 45
Self-observation 5, 54-55
Self-perfection 24-26
Self-realize 67
Self-realized 55
Self-reflection 63
Selfish 5
Selfishness 39
Semen 22, 25, 34-35, 61, 64
Seminal Ejaculation 65
Seminis 24-28, 64
Sensation 63
Sense 3, 17
Senses 2
Sensorial 1
Sensual 1-4, 9-10
Sentimentalism 39
Separate 3, 62
Septenary 26
Serene 11
Serenely 21
Serenity 55
Serious 5, 48
Sermons 51
Serpent 19, 27-28, 65-66
Serve 2, 4-5
Served 18
Serves 2
Service 1
Services 21
Seven 3, 16-17, 26, 29-31, 33-35, 41, 63, 65-67
Seven Centers 3
Seven Cosmos 16-17, 29-31, 33-35
Seventh 31-32, 34
Severe 6, 21, 41
Sevohtartra 21
Sex 4, 61
Sexes 68
Sexual 3, 9, 22-23, 26-27, 34-35, 46, 60-61, 64-67
Sexual Fire 23, 66

Sexual Magic 22, 34-35, 46, 60-61, 65
Shackles 53
Shape 56
Shiemash 22, 57-58, 60
Shine 7, 60
Ship 20
Short 49, 54
Shoulders 22
Showed 57
Showing 11
Shown 19, 65
Sickening 7
Siddhis 7, 14-15
Significance 25, 59
Significant 53
Signifies 27-28
Signify 5
Silence 53-55, 58-60
Silenced 53
Simple 1, 64
Simplicity 67
Sin 27
Sing 50
Single 54
Sins 63
Sirius 29
Sisters 6, 9, 14, 18, 22, 25, 32, 45, 60
Situation 10, 21, 63
Six 13, 32-35
Sixth 31-33
Skandha 61
Skinny 27
Slaves 5
Sleep 48, 52
Sleeps 48, 51-52, 64
Slow 66
Slowly 19, 66, 68
Slums 64
Small 17, 29, 31, 47
Societies 4
Society 25
Solar 9, 17, 24, 29, 31-32, 35-36, 43,
 64, 67
Solar Astral Body 9
Solar Bodies 35-36
Solar Body 43
Solar Man 64
Solar Mental Body 9

Solar System 17, 29, 31-32
Solar Wisdom 24
Son 33
Song 50
Sorrowful 33
Soul 12, 19, 41, 47, 56, 64-65, 67-68
Souls 33, 61, 67-68
Sounds 7
Source 61-62
Space 29, 55, 63
Spark 64-65
Speak 19, 57
Speaking 14, 67
Special 53
Specter 61
Speculations 1, 6
Sperm 25-26
Sphere 65
Spilling 61
Spinal 34, 66
Spiral Path 62
Spirit 33, 35, 41, 64, 67
Spirit of Life 35
Spiritual 14, 29, 56
Spiritualists 66
Spot 33
Squanders 13-14
Star 60
Stars 64
Starship 19
Start 1, 4, 14
Started 20, 25
Starts 33
State 11, 19, 21, 25, 39, 46-47, 52, 54,
 58-60, 63
Stella Maris 6
Steps 64
Stigma 21
Still 2, 5, 19, 26, 35, 53-56, 58
Stillness 53-54
Stones 50
Stop 5, 15, 20, 49, 52
Stopped 51
Story 10, 18, 66
Straight Path 62
Strange 7, 40
Street 10, 50
Streets 9, 11

Strength 45, 64
Strengthened 23
Strengthening 45
Strengthens 42
Strong 45
Structured 4, 14
Struggle 4, 9-10, 49, 51, 61
Student 55, 61
Students 34-35, 43, 46, 60
Studied 2
Studies 62
Study 30-31, 48, 53, 55, 58-59
Studying 20
Stupid 45, 59
Stupidly 47
Subconscious 36, 48
Subconsciousness 22, 41, 46-48
Subject 34
Subjective 1-2, 5-6
Subjectively 2
Sublunar 31
Submerge 47
Submerged 31, 59
Submerged Mineral Kingdom 31
Submerging 25
Submitted 26, 37
Subordinate 4
Subordinates 67
Subsequently 65
Substance 34
Substances 26, 34
Subtle 41
Subub 54, 59-60
Succeed 58
Success 25, 50
Successive 39, 55
Suffer 7
Suffered 22, 24-25, 58
Suffering 57, 61-63
Suggestion 62
Suicide 21
Suit 41, 43
Sum 63
Summarized 55
Sumptuous 4
Sun 17, 29, 31-32, 66
Sung 50
Suns 29, 31-32

Superfluous 26
Superior Bodies 8, 34
Superior Worlds 48, 51
Supermarket 10-11
Supersensible 67
Supplied 20
Suprasensible 47-48
Supreme 62
Surpasses 53
Survive 25
Survived 25
Suspicions 21
Sustained 49
Swears 39-40
Symbolic 21
Symbolized 66
Symbols 51
Synthesis 27, 55, 61, 67
System 17, 29, 31-32, 34, 53, 66
Systems 2
Tail 19, 23, 65
Talk 62
Talking 13, 51
Tall 49, 54
Tantra 65, 68
Tantric 24-25
Tao 50
Tarot 62, 67
Tartarus 31
Teach 22-23, 61
Teachers 68
Teaches 2, 11
Teaching 29
Teachings 59, 62-63
Tears 37-39, 42-43
Technique of Meditation 53, 55, 59
Teenager 1-2
Tempest 53
Temporal 37
Tempting 9, 47
Ten 15, 17-18
Tendency 6
Tenebrous 20, 27, 31, 54, 59-60
Tension 51, 56
Term 62, 64, 66-67
Termination 66
Terrestrial 66
Tests 66

Tetrasustainers 21
Theoretical 6
Theories 61
Theosophist 36
Think 5, 50, 55
Thinking 34, 49, 51, 53, 55
Thinks 65
Third 2, 8-9, 13-14, 29, 32-33, 45, 57, 66
Third Factor 8
Thirty-five 25
Thought 54
Thoughts 48, 50, 55
Thousand 13
Thousands 39, 42
Three 3, 8, 13, 21-22, 29, 32-33, 35, 42, 46, 57, 63-64, 68
Three Brains 3, 63
Three Factors 8, 22, 46
Threshold 61
Threw 22
Throne 21
Tibet 22, 43, 62
Tibetan 61-63
Time 1-2, 7, 11, 15, 21, 37, 41-42, 55, 67-68
Times 6, 19, 57, 65
Tiphereth 62
Tlaloc 66
TO BE BORN 8, 39, 46
TO DIE 8, 39, 46, 48
To Soma Heliakon 64
Today 19, 39-40, 66
Tomb 42
Tomorrow 40, 68
Tonantzin 6
Topics 2
Torment 43
Torrential 50
Total 21
Totality 7, 17, 64
Totally 51
Toy 2
Trace 55
Tradition 19, 24-25, 57, 66
Traditions 19, 21, 25-26, 61
Tragedies 43
Tragedy 21

Tragic 39
Transcended 65
Transcendental 15, 17, 60
Transcends 37
Transform 67
Transformation 2, 5, 64
Transformed 48
Transforms 20, 37
Transmute 28
Transmuted 26
Trap 61
Trapped 61, 64
Travel 61
Tree of Life 16
Triad 67
Trillions 67
Triple 46
Tritocosmos 17, 31-32
True 3-4, 8, 14-15, 17, 20, 45-46, 64
Truth 2, 15, 54, 56, 59, 63
Try 6, 11, 50
Turbid 51
Turn 11, 15
Turned 10
Turns 33
Twelve 32-34
Twenty-four 32-34
Twist 13
Two 3, 10-11, 20, 26-27, 29, 37, 41, 45-46, 49, 54-55, 57, 63, 66
Tyranny 50
Ugliness 55
Ummom 53
Unawareness 52
Unconsciously 20
Understand 3, 6, 9, 13-15, 63
Understanding 53
Understood 2-3, 5, 14, 17, 21-22
Undesirable 7-8, 14
Unique 32-33, 59
Unit 67
Unite 54
United 66
Unity 67
Universal Gnosticism 63
Universe 21, 33
Universities 2
University 1

Unmanifested 29, 34
Unpleasant 54
Unutterable 58
Unwritten 59
Urgent 4, 14, 60
Used 15, 64
Useful 65
Usefulness 9
Useless 10
Utilize 14
Utilizes 43
Utopianism 1, 6
Vacillate 53
Vain 19, 24-25
Valley 33, 35, 37-39, 42-43
Valley of Tears 37-39, 42-43
Value 61
Values 64
Vanity 47
Variant 6
Variation 6
Various 42, 63
Vast 29
Ve 15
Vehicle 10, 67
Vehicles 3, 8, 13, 36
Verify 20
Versa 27
Vestiges 28
Vezinian 57
Vibrations 27
Vice 27
Vices 61
Vicious 1
Victory 21, 50
Vigil 52
Vigilance 52
Violate 62
Violence 53
Violently 10, 53, 62
Virgin 6
Virtue 27, 64
Virtutis 25, 64
Vishnu 62
Vision 49
Vital 14, 35, 41-42, 63, 67
Vital Bodies 42
Vital Body 35, 41-42

Vivid 6
Vociferous 11
Void 58
Volcanoes 66
Volitive 14
Volumes 48
Voluntary 57
Vulcan 65
Waited 11, 13
Waiting 13
Walk 50, 53, 61
Walking 50
Walks 61
Wander 9
Wanders 42, 68
Want 4, 6-7, 9-10, 13, 15, 46, 49, 62
Wanted 11
Wants 20, 49, 67
Warnings 51
Wars 25
Washroom 54
Waste 8, 14
Wasted 13
Wastes 47
Wasting 11, 13, 15
Water 39, 57, 63
Waters 51, 64
Way 2, 4-5, 7, 10-11, 13, 17, 22, 26-27,
 29, 32, 42, 49, 52, 61, 63
Weapons 20
Weighs 19
Well 11, 14-15, 17, 22, 24-25, 27, 39,
 48, 51
Western 55
Wheel 38, 42
Wheel of Destiny 42
Wheel of Samsara 38
White 22-23, 45-46, 61, 65, 68
White Lodge 46, 61
White Magic 45, 68
Whole 13, 17, 20-21, 25, 35, 37, 55
Wife 65-66
Wilderness 9
Winds 61
Wine 4, 10
Wisdom 3, 24-25, 62
Wise 5, 15
Wish 60

Witches 65
Woman 3, 11, 14, 18, 40
Womb 41, 43
Women 36
Wonder 2
Wonderment 60
Woods 59
Word 3, 7, 17, 19, 27, 58, 62-63, 66-67
Words 9, 18, 54-55, 57, 64, 67-68
Work 3-5, 8, 15, 25, 33-35, 45, 48, 51,
 55, 58, 60, 65
Worked 15, 43
Working 46, 51, 62, 65
Works 62, 64
World 3, 5, 9, 20-21, 31, 33-36, 39, 41,
 43, 45, 48, 51-52, 54-55, 57, 62, 67
Worlds 29, 31-32, 36, 47-48, 51-52
Worship 9
Worships 61
Writers 36
Writings 29
Written 9, 46
Year 56, 59-60
Yearners 26
Yearning 24-25
Years 19, 21, 41, 43, 64, 67
Yellow 15
Yoni 67
Youth 1-2, 39, 55

Books by the Same Author

Aquarian Message
Aztec Christic Magic
Book of the Dead
Book of the Virgin of Carmen
Buddha's Necklace
Christ Will
Christmas Messages (various)
Cosmic Ships
Cosmic Teachings of a Lama
Didactic Self-Knowledge
Dream Yoga (collected writings)
Elimination of Satan's Tail
Esoteric Course of Runic Magic
Esoteric Treatise of Hermetic Astrology
Esoteric Treatise of Theurgy
Fundamental Education
Fundamental Notions of Endocrinology
Gnostic Anthropology
Gnostic Catechism
The Great Rebellion
Greater Mysteries
Igneous Rose
The Initiatic Path in the Arcana of Tarot
 and Kabbalah

Introduction to Gnosis
Kabbalah of the Mayan Mysteries
Lamasery Exercises
Logos Mantra Theurgy
Manual of Practical Magic
Mysteries of Fire: Kundalini Yoga
Mystery of the Golden Blossom
Occult Medicine & Practical Magic
Parsifal Unveiled
The Perfect Matrimony
Pistis Sophia Unveiled
Revolution of Beelzebub
Revolution of the Dialectic
Revolutionary Psychology
Secret Doctrine of Anahuac
Three Mountains
Transmutation of Sexual Energy
Treatise of Sexual Alchemy
Yellow Book
Yes, There is Hell, a Devil, and Karma
Zodiacal Course
150 Answers from Master Samael Aun Weor

To learn more about Gnosis, visit gnosticteachings.org.

Thelema Press is a non-profit publisher dedicated to spreading the sacred universal doctrine to suffering humanity. All of our works are made possible by the kindness and generosity of sponsors. If you would like to make a tax-deductible donation, you may send it to the address below, or visit our website for other alternatives. If you would like to sponsor the publication of a book, please contact us at 212-501-6106 or help@gnosticteachings.org.

Thelema Press
PMB 192, 18645 SW Farmington Rd., Aloha OR 97007 USA
Phone: 212-501-6106 · Fax: 212-501-1676

Visit us online at:
gnosticteachings.org
gnosticradio.org
gnosticschool.org
gnosticstore.org
gnosticvideos.org